IMAGES
of America

CHIPPIANNOCK
CEMETERY

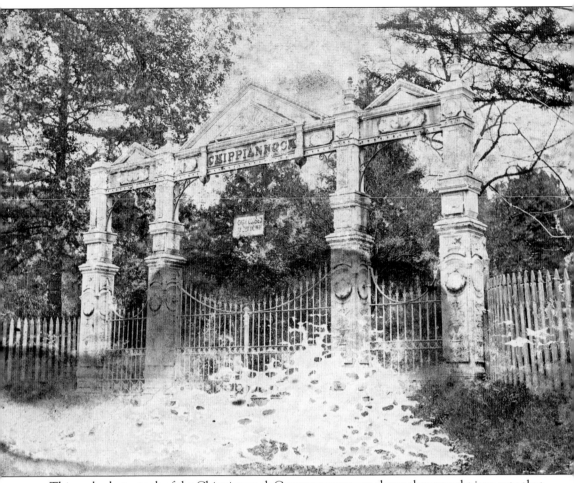

This early photograph of the Chippiannock Cemetery entrance shows the wrought-iron gate that once welcomed mourners and visitors into the cemetery. The date of the erection of the iron gate is unknown, but it was in place as of 1915. (In another photograph, the Soldiers and Sailors Monument can be seen through the gate in the background, and the monument was dedicated in 1915.) The gate was dismantled and used as scrap metal during World War I. (Courtesy of Chippiannock Cemetery.)

ON THE COVER: Brussels sculptor Paul DeVigne created the stunning monument for Philander Cable's family plot. Cast in bronze and shipped to the United States from Belgium, the sculpture depicts a life-size mourning woman reaching up toward a sarcophagus. In 1856, Cable (1817–1866) and his friend Philemon Mitchell (whose family plot is next to Cable's) came to Rock Island with $80,000, which they invested in banks, coal mines, and railroads. (Courtesy of author.)

IMAGES
of America

CHIPPIANNOCK
CEMETERY

Minda Powers-Douglas

ARCADIA
PUBLISHING

Published by Arcadia Publishing
Charleston SC, Chicago IL, Portsmouth NH, San Francisco CA

Printed in the United States of America

Library of Congress Control Number: 2009931248

For all general information contact Arcadia Publishing at:
Telephone 843-853-2070
Fax 843-853-0044
E-mail sales@arcadiapublishing.com
For customer service and orders:
Toll-Free 1-888-313-2665

Visit us on the Internet at www.arcadiapublishing.com

To Greg Vogele, Jillian Bishop, Tracey McVay, and the entire staff of Chippiannock, now and through the years. You keep this cemetery alive.

CONTENTS

ACKNOWLEDGMENTS

Walk through Chippiannock Cemetery and you know it's a special place. While the history is fascinating, and the grounds are beautiful, there is something more to the cemetery than meets the eye. There is a feeling of timelessness.

While this is not the first book written about Chippiannock, I hope it will not be the last. There are still so many stories to tell. Many thanks to Jill Doak, the editor of *150 Years of Epitaphs at Chippiannock Cemetery*, for the inspiration and information; to the researchers and script writer (Charles Oestreich) for *Epitaphs Brought to Life*; and to Terri Wiebenga, author of *Passages: A Collection of Personal Histories of Chippiannock Cemetery*.

Thank you to the Rock Island County Historical Society and Museum and all the volunteers. Everyone at RICHS does a fantastic job preserving our local heritage. Thank you!

I cannot give enough thanks to Greg Vogele of Chippiannock, who was kind enough to allow me the opportunity to write about the cemetery. As his family has been a part of Chippiannock for three generations, I hope I've done justice to this wonderful landmark. The information you have shared with me has been eye-opening and fascinating. Your work with Chippiannock, Calvary, and Rose Lawn is an inspiration. You truly make a difference to our community.

Thank you to Jillian Bishop, who put up with countless questions and Facebook posts. Thank you also to Jared Vogele, Tracey Baker, and Chippiannock Board member Jill Doak for your time and assistance.

To my editor at Arcadia Publishing, Jeff Ruetsche, thank you for your guidance and encouragement. The creation of this book has been a learning experience in so many ways. Thank you to Bill Douglas for his artwork, B. A. Summers for the use of images from her personal collection, and to the Figge Art Museum for permission to reproduce the "River of Life" Tiffany window.

I would like to thank my husband, Bill, and my daughter, Bella, who were so understanding during the process of writing this book and for supporting me the entire time. You guys are my heart.

Unless otherwise noted, all images appear courtesy of the author. (Photographs were either taken by the author or come from her personal collection.)

INTRODUCTION

Even before the land was officially purchased, the cemetery had a name: Chippiannock. Meaning "village of the dead" in the Native American dialect of the Sauk and Foxes, Chippiannock (pronounced "chip-eye-an-nock") was a fitting name for a cemetery rich in history and created by a dedicated community. It was built on the former land of the Sauk nation in what is now Rock Island, Illinois, between the Mississippi River and the Rock River (once known as Sen-i-se-po or Sinnissippi).

Until Chippiannock was established in 1855, there was no official burial ground in what is now the quad-city area (Rock Island and Moline, Illinois, and Davenport and Bettendorf, Iowa). Before that time, people in Rock Island were buried on family-owned property or in a pasture owned by Bailey Davenport, the five-time mayor of the city. Davenport was on the original Chippiannock Cemetery Association's board of directors, and it was his mother, Susan Lewis Goldsmith, who selected the cemetery's name.

Chippiannock Cemetery was founded during what is called the golden era of cemeteries. Elaborate burial grounds were being established to take the place of the currently over-full burial locations and to meet the needs of growing populations. These cemeteries were known as rural or garden cemeteries.

The first garden cemetery in America was Mount Auburn in Cambridge, Massachusetts. It was founded in 1831 and designed by Gen. Henry A. S. Dearborn, with the assistance of the city's horticultural society. Inspired by Père-Lachaise in Paris, France, Mount Auburn had meandering paths, lush foliage, ponds, and wooded areas. It was no wonder that Mount Auburn soon became a tourist attraction. In fact, these types of garden cemeteries became America's first public parks. Families would not only visit cemeteries to pay their respects for their lost loved ones, they would also go to enjoy the natural surroundings and even socialize. It was not rare for visitors to have picnics and take carriage rides through the grounds.

In her essay "Leisure Uses of 19th Century Rural Cemeteries," Blanche Linden-Ward noted that a Victorian-era writer named Lydia Maria Child "urged women to take their children on Sunday walks through the cemetery: 'So important do I consider cheerful association with death.'" Linden-Ward also said, "Mount Auburn was meant to be a didactic, soothing, restorative place for all ages, all religions, and all classes."

Manitou Ridge was the chosen location for Chippiannock and, as its name suggests, the cemetery would be built from the bottom to the top of a bluff. Almerin Hotchkiss, a civil engineer who had also designed Bellefontaine Cemetery in St. Louis, Missouri, and Lake Forest Cemetery in Lake Forest, Illinois, was selected to design the cemetery. Chippiannock would become the first designed landscape in Illinois.

Chippiannock is the resting place of colonels, mayors, railroad tycoons, coal mine moguls, steamboat captains, Civil War soldiers, judges, blacksmiths, and a variety of community philanthropists. In this cemetery, there are war heroes and local heroes, entrepreneurs and

politicians, madams and madmen, beloved children and centenarians. Striking monuments of the finest detail are next to the most primitive of markers that are beautiful in their own right. People can bird watch, walk along the pathways, and enjoy the arboretum that is Chippiannock. Throughout the grounds there are evergreens, elms, maples, oaks, hemlocks, walnuts, magnolias, lindens, red buds, catalpas, cedars, locusts, and a variety of fruit trees, which are common to the area. One will also find the more rare species of trees for this area, such as persimmon trees, white cedars, and French trees.

Stately monuments are easily spotted throughout the cemetery, including life-size statues of mourning women, anvils, dogs, a 6-ton sphere, and real anchors. One of the most prominent and spectacular monuments is at the grave site of Philander Cable. Cast in bronze in Brussels, then shipped to Rock Island, the monument consists of a large sarcophagus on an even larger base. A life-size woman in bronze reaches up against the base next to the Cable name. In her hand are long, flowing feathers. Cable was a railroad tycoon who also had interests in coal mining. He was an excellent businessman who was well respected in the community.

While other monuments include elegant mausolea, towering obelisks, and intricately carved Victorian markers, the grave markers that have the strongest effect on visitors are those for the children. At the graves of the Dimick children is the statue of a Newfoundland dog lying sadly next to them. The gravestone of Jamie Sax is an actual-size cradle, carved in heartbreaking detail. Carvings of curly wooled lambs and even infants in repose on tiny beds represent the loss of the tiniest of family members.

Chippiannock has always been a special cemetery, welcoming mourners, walkers, joggers, tourists, artists, and visitors of every sort and features more than 100 species of trees. On July 21, 2008, Chippiannock became a disaster area. A terrible windstorm, known as a derecho, struck the grounds with brutal force, destroying more than 125 trees and knocking over an unknown number of tombstones. Upon entering the grounds later that morning, superintendent Gregory Vogele (the third consecutive generation of his family to serve as superintendent at Chippiannock) was shocked and devastated. One of the grand magnolia trees near the gates was down, as was one of the largest persimmon trees in the area. That day, he started evaluating the damage, and he and his staff began the enormous task of clean up.

The winds had not been discriminatory. Both old trees and new trees had been ripped apart. Branches were strewn everywhere; entire trees were ripped from the earth, leaving enormous root balls exposed. A number of the roadways were blocked by large branches or whole tree trunks. It was impossible to know how many gravestones had been knocked over or broken because they couldn't be accessed. According to Vogele, the damage was estimated at $98,000, which was approximately the cemetery's annual budget.

One thing the storm has done for Chippiannock was remind the community of the importance of our cemeteries. A community's cemeteries are living, outdoor museums built around its history and people. One does not have to have a loved one buried in Chippiannock; walking through the grounds, everyone will find that they are surrounded by the community's founders and builders. The cemetery becomes a part of each person. It is filled with the many cultures that make up who we have been and who we are.

One hundred volunteers came to Chippiannock on August 9, 2008, to help clean up the grounds and preserve this precious village of the dead for generations to come. Their efforts not only gave the cemetery's staff the morale boost they needed to forge ahead, it also helped the rest of the community understand that the resting places we once thought were eternal are also fragile . . . and deserving of our reverence and care.

Today, over one year after the big storm, Chippiannock is cleared of the fallen trees and new ones have been planted. The grounds have some new vistas, and there are some remaining stumps to remind visitors of handsome, old trees that once stood. But the cemetery is still beautiful and stands its silent sentry overlooking western Rock Island. The hard-working staff can look up the bluff at an ongoing job well done and a reminder of how one cemetery brought a community together.

One

Village of the Dead
The History of Chippiannock

In 1855, Rock Island opened the gates to its first official cemetery. Chippiannock Cemetery has played an important role in the Rock Island and surrounding communities for more than 150 years. The exact date of this photograph is unknown, but the Soldiers and Sailors Monument, which can be seen through the gates in the center of the photograph, was erected in 1915, and the iron entrance gates were removed for scrap metal during World War I. (Courtesy of Chippiannock Cemetery.)

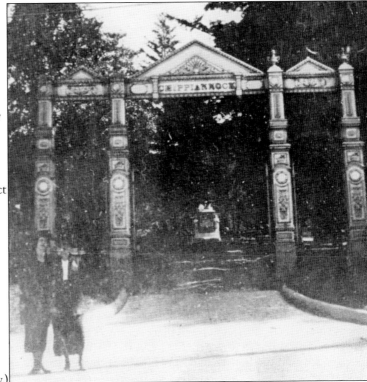

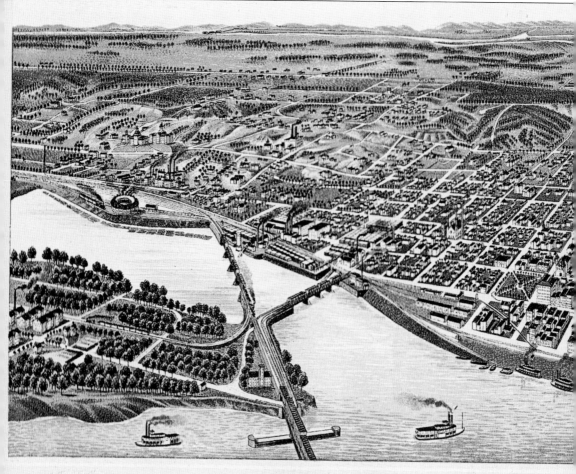

BIRDS-EYE-VIEW OF R(

The beauty of the Rock Island area led many to choose it for their home, and it would eventually become their final resting place. Illinois governor John Reynolds (fourth state governor, 1830–1834) once said, "The scenery about Rock Island is not surpassed by any in the whole length of the Mississippi. It seems as though Nature had made an effort in forming this beautiful and picturesque country." The original Rock Island is what is now known as Rock Island Arsenal or Arsenal Island. It is the largest island in the Mississippi River. According to *Historic Rock Island*

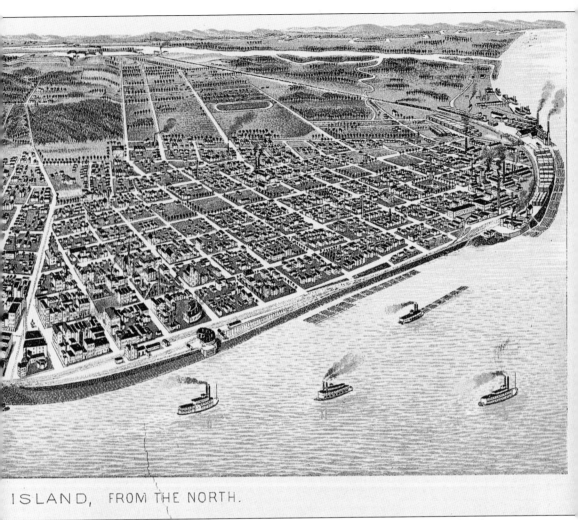

ISLAND, FROM THE NORTH.

County, "the island in the Mississippi known as Rock Island is a great mass of Hamilton limestone. . . .[It is a] splendid island surrounded by the bright waters of the Mississippi and bounded by the outlying bluffs like unto a spacious amphitheater changing with the seasons." This photograph of Rock Island was taken in February 1903 from the Davenport shoreline. (Courtesy of Rock Island County Historical Society.)

MISSISSIPPI
RIVER

Air View, Rock Island, Illinois

Rock Island was originally named Stephenson, after Col. Benjamin Stephenson, who was born in Pennsylvania in 1769 and eventually came to the Illinois Territory and served as a representative in the U.S. Congress from 1814 to 1816. He was involved in writing the first constitution for Illinois in 1818 and was a commander in the War of 1812.

Like many early cemeteries, Chippiannock was once located on the outskirts of the town. As Rock Island developed and grew, houses and businesses started getting closer to the peaceful grounds. Even though the cemetery is now surrounded by housing, businesses, and busy streets, it is still a quiet sanctuary filled with the flora and fauna originally intended. This photograph is from 1931. (Courtesy of Chippiannock Cemetery.)

The correct pronunciation of Chippiannock (meaning "village of the dead" in the Sac and Fox languages) is "chip-eye-an-nock." Susan Lewis Goldsmith, stepdaughter of Col. George Davenport and mother of Bailey Davenport, selected the name for the cemetery. Susan was fluent in the native language, as she had moved to Rock Island (now the Arsenal) in 1816 and "saw no other white woman except her mother" for five years, according to the *Town Crier*. In 1931, the cemetery's name was once "embossed in flowers on the terrace facing Twelfth Street." While the name in flowers is no longer there, Twelfth Street remains paved in brick. These images appear in the 1931 booklet created by the cemetery. (Courtesy of Chippiannock Cemetery.)

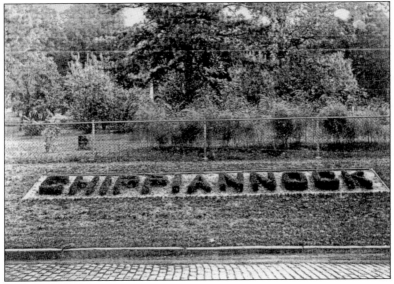

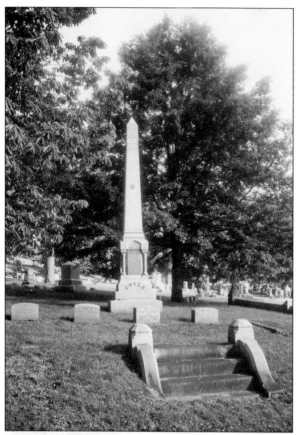

The men who came together in 1854 with the idea of establishing a formal cemetery for Rock Island became the Chippiannock Cemetery Association's first board of directors: Bailey Davenport, Samuel S. Guyer, Holmes Hakes, William L. Lee, and Henry A. Porter. The land they proposed for the cemetery was between Rock Island and Camden (the original name for Milan, Illinois). Before the land was officially purchased, Davenport's mother, Susan Lewis, named the cemetery "Chippiannock." The association purchased 62 acres from Ebenezer Lathrop. Approximately $6,000 was spent to transform the grounds. Each of the original board members is buried at Chippiannock (the graves of Guyer and Hakes are shown here). Hakes was an original trustee of the Village of Rock Island, drafting the city charter with Napoleon Buford and James Hadsell. He also was one of Chippiannock's presidents. For more on Guyer, see Chapter Six.

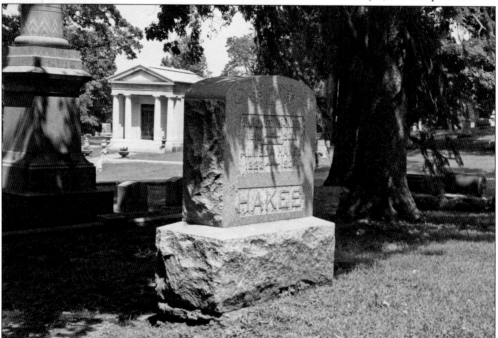

Bailey Davenport (1823–1890) was one of Rock Island's most important citizens. He was a horse trader during the Black Hawk War, a West Point graduate, assistant postmaster general, and the five-time mayor of Rock Island. He owned over 2,200 acres of land in the area. Davenport was known for his generosity and business sense. He is buried in the family plot he purchased when he moved his father and grandmother's graves from their location by the family homestead. (Courtesy of Rock Island County Historical Society.)

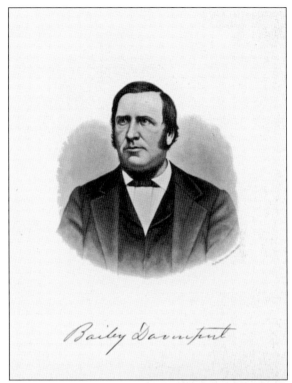

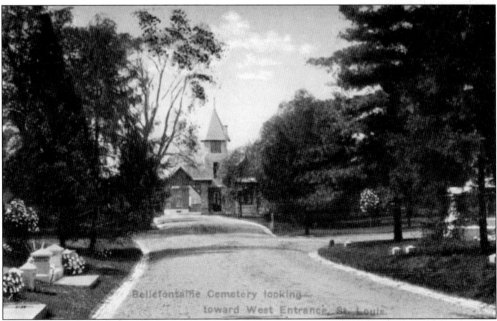

Civil engineer and horticulturist Almerin Hotchkiss was commissioned to design Chippiannock Cemetery by the cemetery's original organizers. Hotchkiss was known for his design of Bellefontaine Cemetery in St. Louis, Missouri, (as shown in this postcard) and Greenwood Cemetery in Brooklyn, New York. He took full advantage of the natural topography and allowed the flow of Manitou Ridge to be maintained.

The sexton's house was on the Chippiannock property before the cemetery was. The house was built in the Gothic Revival style and is believed to have been owned by Ebenezer Lathrop, who also owned the original sixty-two acres of land that would become the cemetery. The bell in the cupola on the roof used to be rung each time a burial took place. The gabled house sits just inside Chippiannock's gates and was the home of the sexton, or superintendent, until recent years.

For three generations, since 1922, a Vogele has been at the helm of Chippiannock Cemetery. Ferdinand P. Vogele (died in 1955) was the cemetery's superintendent from 1922 to 1938. His son, Joseph A. Vogele (1912–1993), took over on January 1, 1938. Joseph's son, Gregory Vogele, became superintendent on January 1, 1977. While Joseph is buried in Chippiannock alongside his wife, Helen, Ferdinand is buried with his wife, Charlotte, in neighboring Calvary Cemetery.

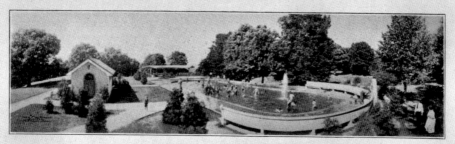

HELEN HORST MEMORIAL

Dedicated to the Children of Rock Island by the Parents of Little Helen
who lost her life in the waters of Rock River

Isaiah 45: 15. 1921 Henry W. Horst
 Mollie Horst

This beautiful pool is situated in Long View Park, high on the bluffs. The view of the river, the
beautiful landscaping effects of shrubs and evergreens, enhance its value as a park attraction.
The kiddies are testing its usefulness.

Before Rock Island had an established cemetery, prominent landowner and multiple-term mayor Bailey Davenport offered his pasture as a burying location for the locals. Eventually this pasture was given to the city and was transformed into Long View Park. The park had two lagoons, gazebos, and this wading pool. The Helen Horst Memorial pool (1921) was built in memory of the little girl who drowned in the Rock River so that local children had a safe place to play.

The remains of those who had been buried in Bailey Davenport's pasture, now Long View Park, were moved to Chippiannock on December 22, 1905. Included in those buried in the unmarked, mass grave on the southeast end of the cemetery are Jeremiah Bowling (November 3, 1788–November 13, 1854) and his wife, Sarah Venable Bowling (December 3, 1794–November 3, 1854).

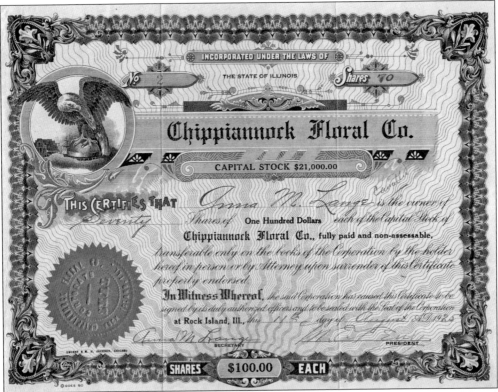

At one time, there was a Chippiannock Floral Company, though it was not known to be affiliated with the cemetery. This cancelled stockholder's certificate belonged to Anna M. Lange and was worth 70 shares at $100 each. It is dated August 11, 1925. At that time, Lange was also the Chippiannock Floral Company secretary. (Courtesy of Rock Island County Historical Society.)

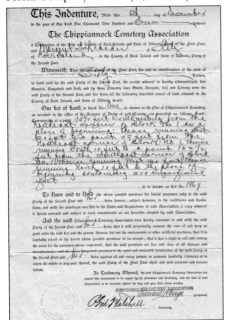

This Chippiannock Cemetery Association (CCA) deed from December 6, 1907, denotes Margeret Schroeder the rights "to have and to hold the above granted premises [lot 1869] for burial purposes only" for herself and her heirs at the cost of $60. The deed is signed by CCA president Edward Guyer and secretary Philemon Mitchell. (Courtesy of Rock Island County Historical Society.)

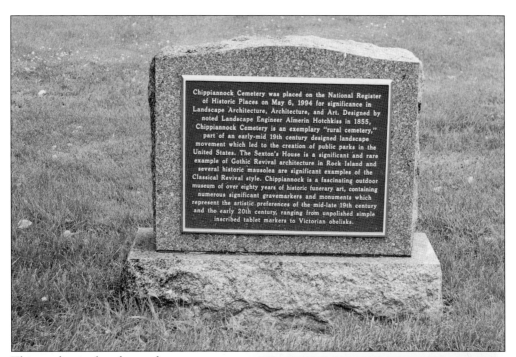

This marker is placed near the entrance of the cemetery. It reads: "Chippiannock Cemetery was placed on the National Register of Historic Places on May 6, 1994, for significance in landscape architecture, architecture, and art. Designed by noted landscape engineer Almerin Hotchkiss in 1855, Chippiannock Cemetery is an exemplary 'rural cemetery,' part of an early-mid 19th century designed landscape movement which led to the creation of public parks in the United States. The sexton's house is a significant and rare example of Gothic Revival architecture in Rock Island, and several historic mausolea are significant examples of the classic revival style. Chippiannock is a fascinating outdoor museum of over 80 years of historic funerary art, containing numerous significant grave markers and monuments which represent the artistic preferences of the mid-late 19th century and the early 20th century, ranging from unpolished simple inscribed tablet markers to Victorian obelisks." This gravestone with an angel coming down to take the woman's soul to Heaven is an exquisite example of Victorian stonework.

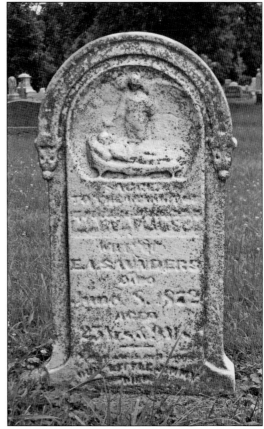

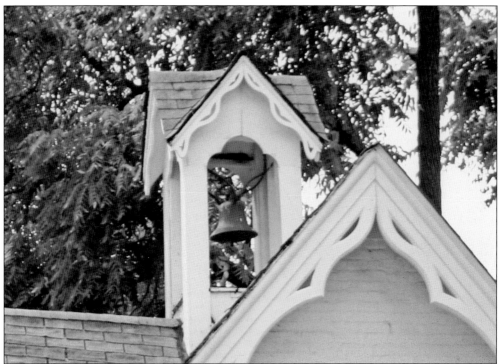

In 1976, the cemetery bell was refurbished after its removal from the small cupola on top of the sexton's house in 1956. The bell was originally made by Meneelys Bell Works in West Troy, New York, in 1855. That year, it was purchased for Chippiannock and rang whenever funeral processions approached the cemetery. The bell weighs 100 pounds. Three generations of Vogeles were there for the placement of the cemetery bell—cemetery sexton Joseph; his son, Gregory (the current sexton/superintendent); and Joseph's grandson, David.

Chippiannock's modern office building was built in 1979. Before that time, the cemetery's office was based in the sexton's house. Through the office, the cemetery sells grave sites, pre-need interments and other pre-need services. The cemetery also sells all types of grave markers. One service that has been growing in popularity is assisting genealogists and other cemetery researchers with information. The staff is happy to help people searching for their relatives' final resting places.

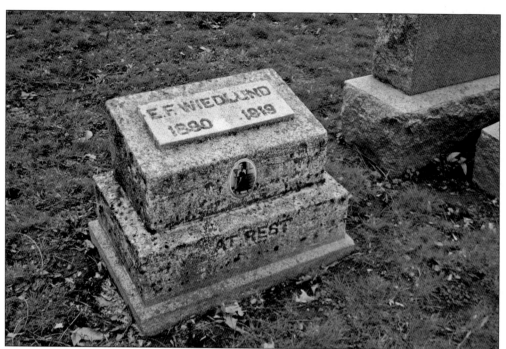

Though Chippiannock is known for its Victorian-era graves, there are of course many fascinating graves from all eras. The grave of Edward F. Wiedlund (1891–1919) is one of these. He was known in the boxing world as Eddie Evers, though his career would only span from 1912 to 1916. Though he had once dreamed of becoming an Olympic boxer, he had diabetes, and it forced him to retire from the game early. He enlisted during World War I but contracted influenza within two short months. Less than a year later, he died at his home at the age of 28. Wiedlund's image is on his gravestone as a photograph ceramic. He is in boxing stance.

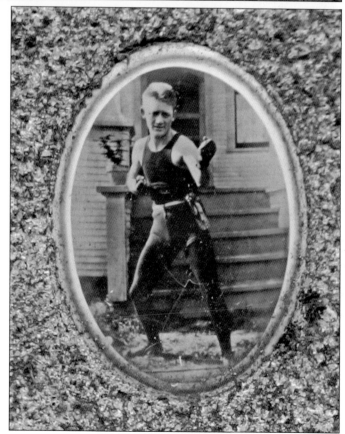

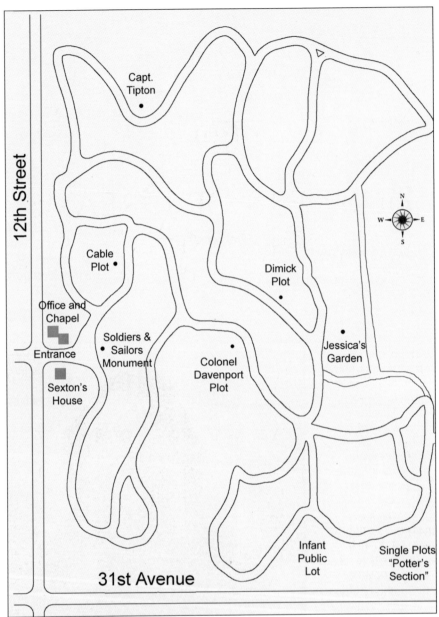

This is a current map of Chippiannock's grounds. A few key plots and areas are noted as reference points, including the entrance off Twelfth Street, the office and chapel, sexton's house, Soldiers and Sailors Monument, Philander Cable plot, Capt. David A. Tipton plot, Col. George Davenport plot, Dimick family plot (where children Eddie and Josie are buried), Jessica's Garden of Angels (infant lot), Infant Public Lot (mainly older graves), and the single plot section also known as the Potter's Section. Maps of the grounds are also available from the office during business hours, and the current walking tour map is available anytime inside the entrance gate near the National Register of Historic Places marker. Walking tour maps through the years include "Chippiannock Cemetery—Grand Epitaphs" (in connection with the 150th anniversary celebration of The Grand Excursion of 1854), "The Best of 'Epitaphs Brought to Life,'" and "Connections: Touched by the Civil War."

Two

BUILDERS OF DREAMS
THE POINEERS

Col. George Davenport (1783–1845) was an English immigrant and the first white man to settle in what is now the Quad Cities. Originally a military man in England, after coming to America (first to New York, then to Pennsylvania) he joined the army and was appointed sergeant. Davenport was later honorably discharged and traveled to Stephenson, Illinois, which would later be called Rock Island. (Courtesy of Rock Island County Historical Society.)

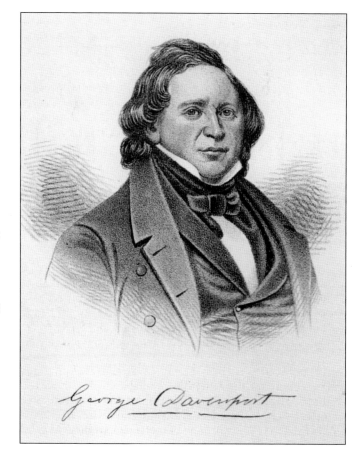

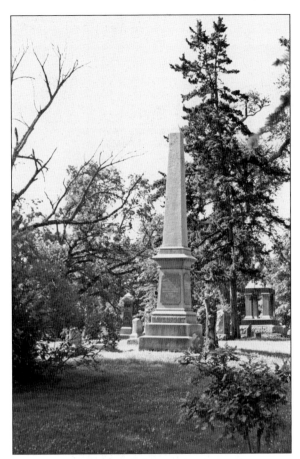

Col. George Davenport was a food trader for the troops on what would become the Rock Island Arsenal. He became quartermaster general with the rank of colonel during the Black Hawk War. Davenport was a well-respected trader among Native Americans in the area and developed strong friendships with them. After the war, he left the trading business to focus on land development on both sides of the Mississippi River. The city of Davenport, Iowa, is named for him.

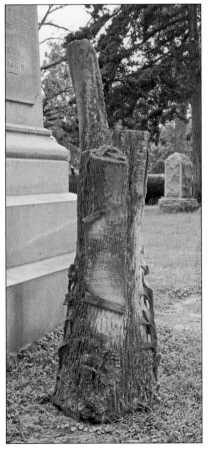

The tree stump marker standing at the base of Col. George Davenport's large obelisk is a replica of the wooden totem pole that Colonel Davenport's Native American friends placed at his grave at Rock Island's Arsenal Island near his home. He and Margaret were moved to Chippiannock after its establishment by his son, Bailey. The marker reads: "These hieroglyphics copied from cedar post erected over the grave of Col. Geo. Davenport by Friendly Indians Sep. 1845."

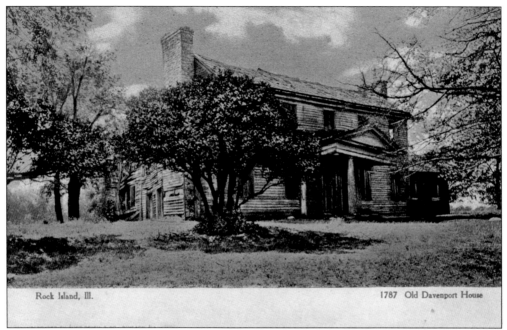

Rock Island, Ill. 1787 Old Davenport House

The home of Col. George Davenport was built on the Rock Island Arsenal. The Davenport homestead was originally a double log cabin, but after a successful career, he built a villa for his family. Now a museum on the island, the Greek revival home can be seen from Davenport, Iowa, across the Mississippi River. Davenport and his wife, Margaret, were originally buried near their home until his son, Bailey, moved them to Chippiannock in 1864. The house still stands today.

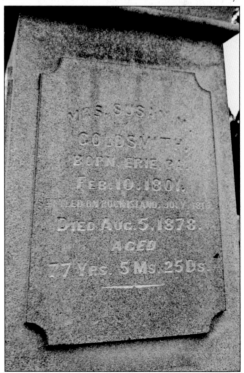

Colonel Davenport married Margaret Bowling Lewis in 1805 after he came to the United States and entered the military. Margaret was 17 years his senior and had two children, William and Susan. Susan Lewis was 5 at time of their marriage. In 1817, George and stepdaughter Susan started having children together, including George and Bailey. Col. Davenport, his wife, stepdaughter, and their children all lived together in their house on Arsenal Island. It was Susan who suggested the Chippiannock's name, which means "village of the dead" in the Sauk and Fox languages.

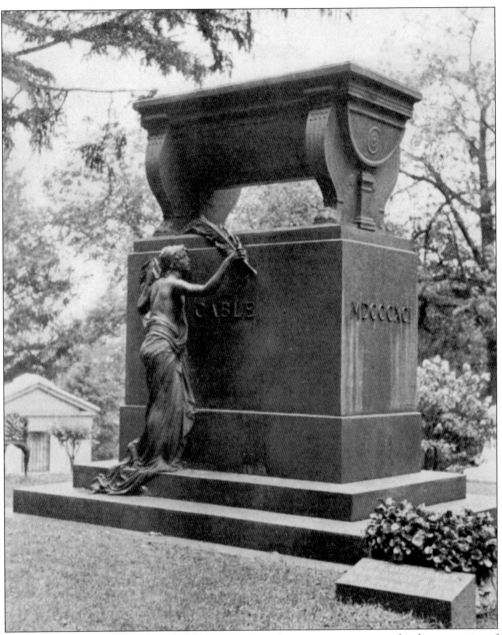

Designed by Belgian artist Paul DeVigne, this large bronze monument marks the grave site of Philander Cable (1817–1886) and his family. Cable's interests were mainly in coal mining and the railroad, though he also owned the banking firm Mitchell and Cable. As the Civil War loomed in 1856, Cable saved many Rock Island businesses by converting their assets to gold when the Southern bonds failed. (Courtesy of Chippiannock Cemetery.)

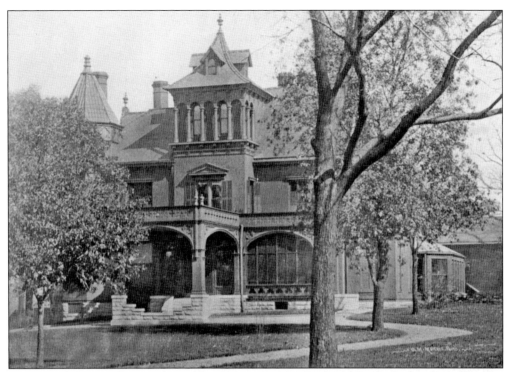

Philander Cable was the president of the Chicago, Rock Island, and Pacific Railroad as well as the Canadian Pacific and other railroads. Philemon Mitchell, whose family plot is located next to Cable's, was his friend and business partner. His son, Benjamin T. Cable, was a member of the Democratic National Committee for Illinois in 1892. He was a Rock Island district congressman. Shown here is the Cable family residence in 1902. (Courtesy of Rock Island County Historical Society.)

Philemon Mitchell came to Rock Island with Philander Cable in 1856. They purchased a bank and ran it together for four years. In 1860, the Mitchell and Cable bank became Mitchell and Lynde when Judge Cornelius Lynde Jr. (buried less than 50 yards from the Mitchell plot) bought out Cable. They eventually formed the first national bank in Rock Island, known as First National. (Courtesy of Rock Island County Historical Society.)

Ransom Reed Cable (1884–1909), nephew of Philander Cable, was president of the Chicago, Rock Island, and Pacific Railway Company. According to Frank Pierce Donovan's *Mileposts on the Prairie*, Ransom Cable "was an old hand at building up strategic railroads, short lines, and partly completed properties which [became] part of the Rock Island System." At the time he became president of the railway company, it was "operating 1,311 miles of line." He left that position in 1898 to become the chairman of the board. He was also a chief executive of the Minneapolis and St. Louis Railway Company. The Rock Island Train Depot (shown in this postcard) was built in 1901 and served as a passenger depot. There were up to 32 daily arrivals and departures. It is Renaissance revival in style and was constructed by John Volk, who is also buried in Chippiannock. The depot has been restored into a banquet facility called the Abbey Station.

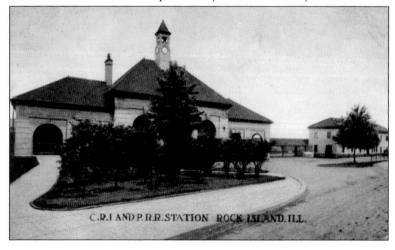

Born in 1801, John W. Spencer came to Rock Island in 1826 with Loudon Case Sr. to see if Native Americans were still living in the area; they believed the land abandoned. As the land was unsettled, Spencer and others used the left-behind wigwams as their homes while building. In his *Reminiscences*, Spencer says it was not long before some Sacs returned, declaring the land wigwams theirs. One of the men was Black Hawk. "We had never heard there was such a chief." (Courtesy of Rock Island County Historical Society.)

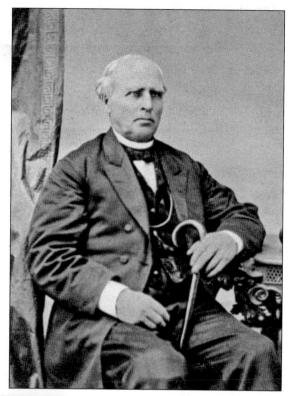

In the winter of 1827, John W. Spencer was paid $5 to travel on foot (or skates on the frozen Mississippi River) 100 miles to the nearest post office in Galena, Illinois, and back. When he returned, be brought news that Abraham Lincoln had been elected U.S. president. He participated in the Black Hawk War, helping organize the Rock River Rangers. He was the Rock Island County Court's first judge.

Archibald Allen moved to Rock Island County, near what is now Port Byron, in 1828. He ran the Archibald Allen Post (he was named the first post master for the county in 1833) out of his home. Allen discovered the Native American trail that led the way to the lead mines near Galena, Illinois. He died of consumption in 1875. (Courtesy of Rock Island County Historical Society; photograph by John Hauberg.)

Joshua Vandruff (1791–1855) was one of the earliest pioneers of what would become Rock Island. He settled here in 1829 and lived side-by-side, mostly peaceably, with the Sauk until they left the area in 1831. In P. A. Armstrong's *Black Hawk War*, the author "declares that Vandruff was the cause of the Black Hawk War." When Vandruff came to Rock Island from Pennsylvania, he brought a whiskey still with him. Black Hawk (below), who had agreed to allow Vandruff to live on his land, was angry that Vandruff continued to sell liquor to his people after he told him to cease. (Vandruff had a history of taking advantage of the drunk Sac.) When Black Hawk broke open gallons of whiskey in retaliation, Vandruff considered it an act of aggression. The Rock River Rangers were quickly formed, and the war began. Joshua was originally buried on Vandruff's Island (named after him) but was moved to Chippiannock after it was established. (Below courtesy of B. A. Summers.)

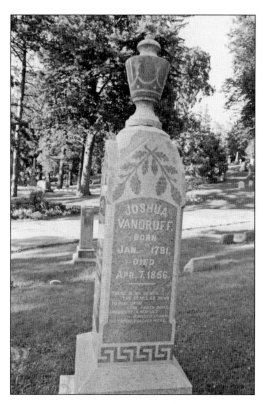

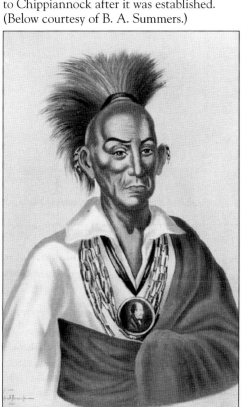

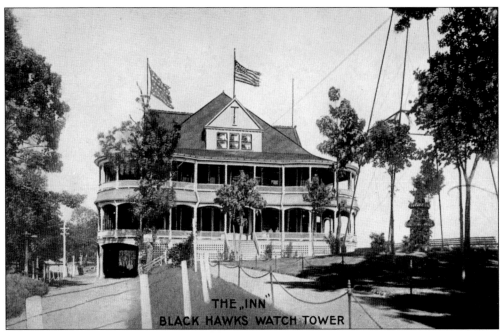

THE „INN"
BLACK HAWKS WATCH TOWER

Bailey Davenport owned "the most popular resort in the county," Black Hawk's Watch Tower (1882–1927). The resort was built on the top of the bluff in the location Black Hawk used as his watch tower. Not only did Davenport's Rock Island and Milan Steam Railway (he was president and superintendent) arrive at the Watch Tower, there was also a streetcar that pulled up at the entrance. Daily attendance ranged up to 15,000. People came from all over to enjoy the live performances, dining, dancing, and amusement rides, including the Shoot the Chutes toboggan slide and the Figure 8 roller coaster (built in 1905). In 1927, after the Watch Tower popularity had faded, the state of Illinois purchased it and transformed it into Black Hawk State Park. In 1987, the park was listed as a state historic site. The Watch Tower Lodge, which was built between 1934 and 1942, was listed on the National Register of Historic Places in 1985.

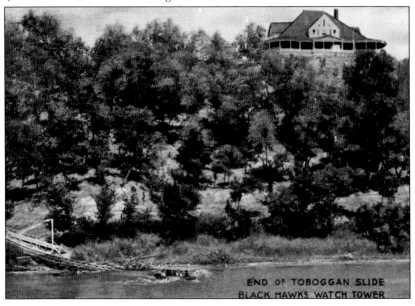

END OF TOBOGGAN SLIDE
BLACK HAWKS WATCH TOWER

According to the *Biographical History of Rock Island*, Peter Fries was a "distiller, banker, and a man of affairs." Born in Bavaria in 1822, he made Rock Island his home in 1854—and eventually became the largest wholesale grocer in the region before he became invested in his other business ventures. In 1887, he donated one of his buildings to a local ladies guild to give them a larger location for the St. Luke's Cottage Hospital they had established.

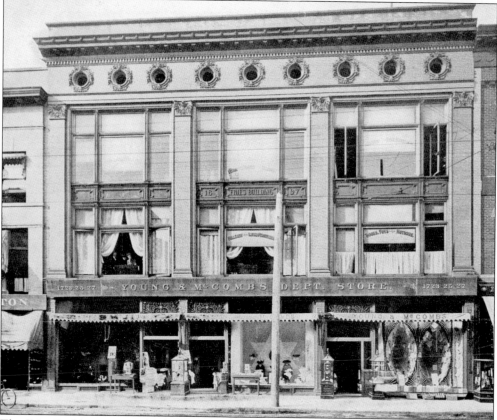

The Fries Building was established in 1897 and still stands downtown at Second Avenue and Seventeenth Street. It is listed on the National Register of Historic Places. At the time of this photograph in 1902, Young and McCombs Department Store was located in the 1723–1727 addresses of the building.

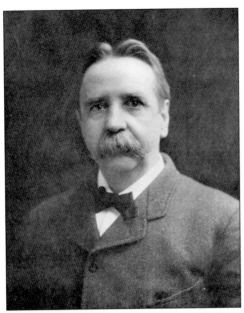

Levi S. McCabe (1846–1915) was a schoolteacher before he went into business as a merchant. Initially he went into business with his brothers, but he bought them out in 1899 and formed L. S. McCabe and Company. He eventually opened stores as far away as Chicago and Des Moines, Iowa. McCabe's interests went beyond being a mere merchant, though. He was vice president of the Moline Central Street Railway Company. That railway later became the Tri-City Railway Company, of which he became a director and large shareholder. (Courtesy of Rock Island County Historical Society.)

McCabe was a president of the Colonial Hotel Company and the Rock Island Safety Deposit Company. He was also involved in a number of other banks as a stockholder or director. According to *150 Years of Epitaphs*, McCabe "platted several large residential additions in Rock Island and Moline." He owned farmland on both sides of the Mississippi River as well as in Nebraska. Considering his many achievements, his grave marker is very understated—a simple granite stone with his name and dates. (Courtesy of Rock Island County Historical Society.)

Ben Harper was a wealthy man who came to Rock Island in 1850. He was the head of the Rock Island Gas Works and was responsible for lighting the homes and streets of the city. He was involved in the development of the Coal Valley mines and the Rock Island-Moline Horse Railway Company. He built the showcase hotel Harper House and the Harper Theatre. Harper was also mayor for one term.

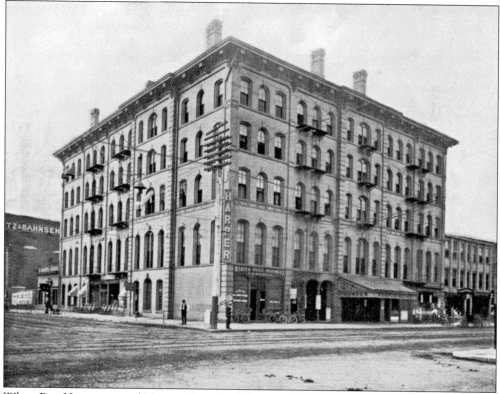

When Ben Harper opened Harper House in February 1871, it became the pride of the Tri-cities (Rock Island, Moline in Illinois, and Davenport, Iowa). The hotel was touted as the "finest hotel between Chicago and the Pacific Coast." Eight hundred guests were present for the grand opening banquet on February 21, 1871, and partook of the 100 items on the party's menu. (Courtesy of Rock Island County Historical Society.)

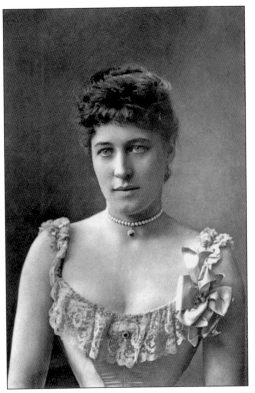

The five-story Harper House was opulent and fashionable. In fact, in 1877, a county directory claimed Harper House was "a better advertisement for Rock Island than three times the money it cost invested in any other business in that city." It was a mainstay of the social elite and hosted a great many celebrities who came to Rock Island to perform, including actresses Sarah Bernhardt and Lillie Langtry (the "Jersey Lillie," shown at left), Charles "Tom Thumb" Stratton (below), Mark Twain, and William "Buffalo Bill" Cody. Other notables who stayed at the Harper House include Civil War generals W. T. Sherman and John A. Logan (who also helped establish Memorial Day as a national holiday). According to the Rock Island Preservation Society, the hotel also had a music store and "Turkish baths, which were reserved for the use of women on weekdays between 9 a.m. and noon." (Both courtesy of B. A. Summers.)

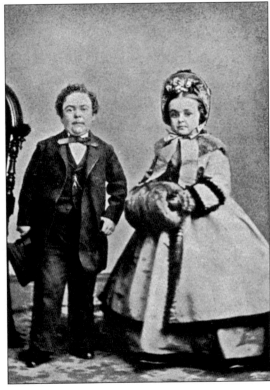

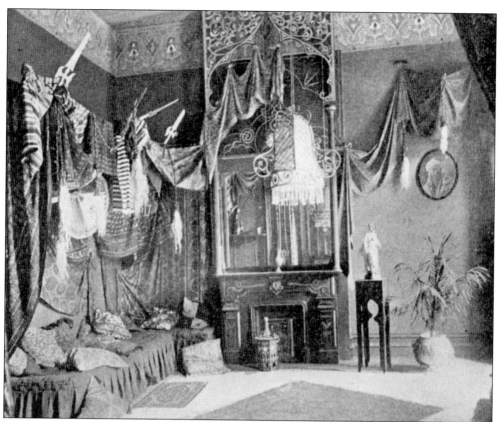

Harper House was the epitome of luxury with its 100 rooms, 1,200-seat auditorium, and many amenities, including a private dining room, oriental parlor, and opulent lobby. The Rock Island Preservation Society says that it was considered "the equal in quality, if not size, to any Chicago hotel." It originally had two 2-story columns and a portico at the main entrance, but these were removed during the 1898 remodeling. The hotel was eventually sold to the DeSilva family in 1908, who owned it until 1964. In 1973, Harper House, this "grand old lady, this queen of Rock Island," was a victim of the wrecking ball. Remnants of Ben Harper's showcase of Rock Island may very well still exist, though. The contents of the hotel, "including the ballroom's crystal chandeliers and grand mirrors as well as ordinary furniture and restaurant equipment, were sold" and may still be in use. (Both courtesy of Rock Island County Historical Society.)

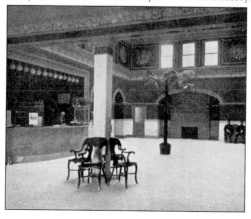

Born in Liverpool, England, in 1834, William Jackson came to Rock Island in 1851 and became a lawyer in 1860. He practiced law for 65 years and took on many high profile cases. Jackson was the president of the Citizens Improvement Association of Rock Island and the first city park commissioner. He was the major visionary behind Spencer Square and Garnsey Square and is known as "the father of the Rock Island park system." Jackson alone raised $6,000 for improving Spencer Square and also raised the bulk of the $16,000 in donations for Long View Park. (Courtesy of Rock Island County Historical Society.)

Christian Frederick Gaetjer (1851–1926) was named the very first city park superintendent for Rock Island in 1908. He oversaw the construction of Long View Park, and before he retired in 1925, his last project was Lincoln Park. For 10 years (1910–1920), Christian and his wife lived in the house that another prominent citizen, O. J. Dimick, built in 1872.

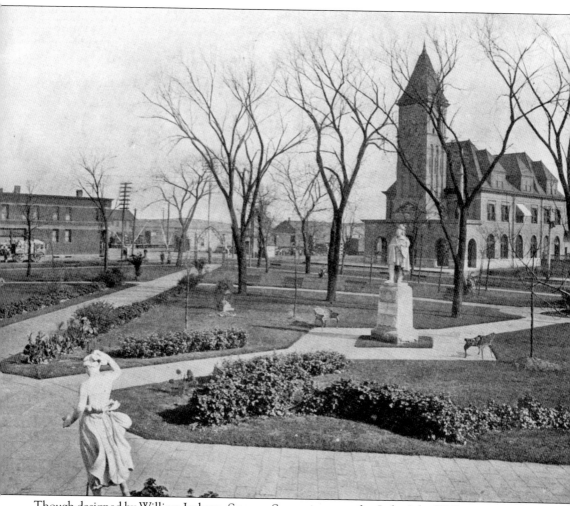

Though designed by William Jackson, Spencer Square is name after Judge John W. Spencer. Jonah Case and John Spencer donated the land the square was built on, and Jackson convinced O. J. Dimick (previously Jackson's sworn enemy) to contribute the money to purchase the statue of Black Hawk. This image of Spencer Square was taken in 1903. (Courtesy of Rock Island County Historical Society.)

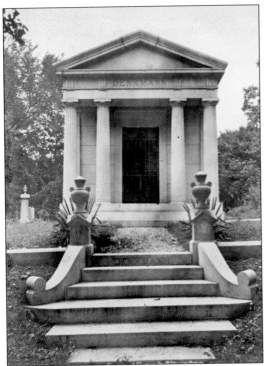

Frederick C. A. "Carl" Denkmann (1822–1905) went from a journeyman machinist to "one of the most prominent lumber men in the world." He and his wife, Catherine (Bloedel), came from Germany and eventually settled in Rock Island in 1851. He was business partners with Frederick Weyerhaeuser, who was married to Catherine's sister, Sarah. Weyerhaeuser and Denkmann Company was king of the lumber mills. At their peak, they owned four mills and output 117 million feet of white pine lumber in one year. (Courtesy of Rock Island County Historical Society.)

Though he was known as the "Timber King," Frederick E. Weyerhaeuser considered himself a man who lived a simple life. But the lumber empire he built with Weyerhaeuser and Denkmann Company was larger than life and extended all the way from Rock Island to Washington State. He was originally a laborer who worked with the railroad and later a sawmill before he began to invest in them. Currently the Weyerhaeuser Corporation is a multimillion dollar company.

Weyerhaeuser and Denkmann Company had a transportation line. Shown here is a pass issued in 1894, which was good "until Dec. 31st 1894, unless otherwise ordered." The back reads: "This pass is good on all steamers of this line between Rock Island, St. Paul and Stillwater. This pass is not transferable, and the person accepting or using it, thereby assumes all risk of accident and damage to person or baggage. If presented by any other than the person named thereon the purser will take it up and collect the regular fare." (Courtesy of Rock Island County Historical Society.)

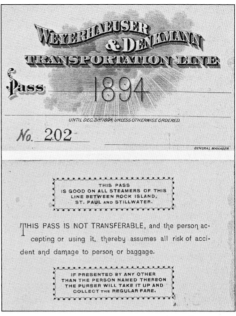

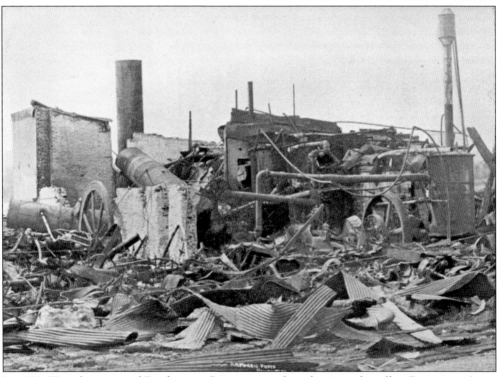

In 1888, Weyerhaeuser and Denkmann Company purchased a riverside mill in Davenport, Iowa, and upgraded it to their high standards. Unfortunately the mill caught fire on July 25, 1901, and burned to rubble. Cutting their losses, Weyerhaeuser and Denkmann decided not to rebuild. It was the first substantial loss to the company in the 41 years since its inception. It did not affect the company's growth, though, as Weyerhaeuser and Denkmann Company was also purchasing mills in other parts of the country.

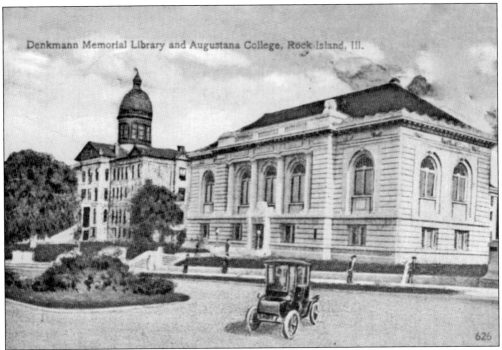

Denkmann Memorial Library and Augustana College, Rock Island, Ill.

626

F. Carl Denkmann's children donated a new building to the Augustana College campus in 1909 on Seventh Avenue in Rock Island, the Denkmann Memorial Library. The building was the campus library from its completion in 1911 until 1990 when a new library was built. Now known as Denkmann Memorial Hall, the building was made of Missouri limestone in the Italian Renaissance style.

Frederick Weyerhaeuser's family is also represented on Augustana College's campus. The Weyerhaeusers purchased the House on the Hill (as it was and is still known). Frederick and Elizabeth (Bladel) Weyerhaeuser moved to Washington State in the early 1900s after his company purchased 900,000 acres of timberland there, leaving the house to their daughter, Apollonia Davis. Upon her death, the house was given to Augustana College in 1954. The house is listed on National Register of Historic Places in 1975. (Courtesy of Rock Island County Historical Society.)

Three

A COMMUNITY OF SERVICE
OUTSTANDING CITIZENS

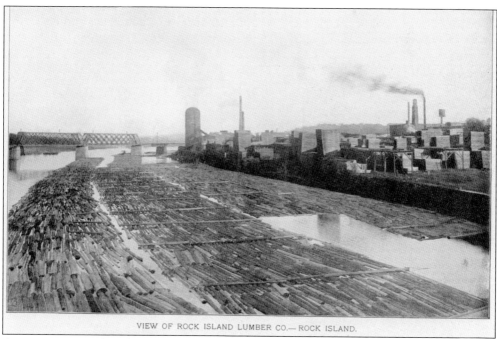

VIEW OF ROCK ISLAND LUMBER CO.— ROCK ISLAND.

A community is only as strong as its citizens, and Rock Island's early citizens were determined and steadfast. They believed that Rock Island was a gem in the raw, and they carved their identity into the limestone and forests of white pine. They filled the mighty Mississippi River with timber and spread the fruits of their labors around the country. Shown here is timber from the Rock Island Lumber Company. (Courtesy of Rock Island County Historical Society.)

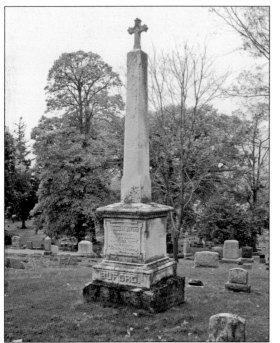

Charles Buford (1797–1866) followed his cousin, John Buford, from Kentucky to Rock Island. Much like John, Charles was against slavery and wished to be free of the South. In 1855, Buford and R. N. Tate established the plow company Buford and Tate, which would become Buford and Company, then Rock Island Plow, and finally J. I. Case. It is rumored that a young Abraham Lincoln was one of the Buford family's notable houseguests. Lincoln visited Rock Island to research the case of *Hurd v. Rock Island Railroad Company.* The Rock Island Plow Company ("manufacturers of agricultural implements") offered their customers annual editions of the Farmer's Pocket Companion. This one is dated 1892. It is also noted on the booklet that the company is the successor to B. D. Buford and Company. (Both courtesy of Rock Island County Historical Society.)

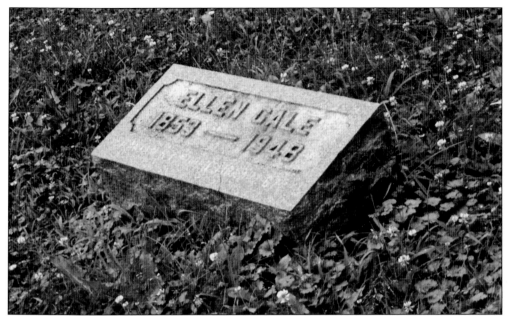

Miss Ellen Gale's simple headstone reads: "Librarian R. I. Public Library 67 years." She became the first female librarian in Rock Island at the age of 15 when she was hired to work for the Young Men's Literary Association in 1868. Miss Gale (as she was always called) then moved to the Rock Island Public Library (the oldest public library in Illinois) when it opened December 15, 1903, until she retired in 1937.

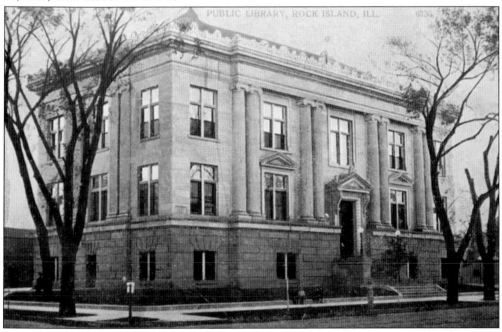

According to the City of Rock Island's Web site, the Rock Island Public Library is the oldest public library in Illinois. It was originally established as a Reading Association for men in 1855. In 1872, it became the first official free library in the state. By 1899, the library had nearly 15,000 books in its collection. This building (the current main library of Rock Island) opened in December 2003.

John Potter was born on August 17, 1861, in Skibbereen, Ireland. He was four when his family came to America, and he started learning to be a printer like his father when he was nine. At one-time Rock Island postmaster, Potter took over the *Rock Island Argus* as editor and publisher in 1882. It was a labor of love for the man, as he led the production of weekly and daily editions. He died in 1898, and his wife, Minnie, took over the paper, forming the J. W. Potter Company, becoming its president. It was rare for a woman to hold such a position, but she did so for 27 years. Under her leadership, the *Argus* became the leading paper in the area. (Both courtesy of Rock Island County Historical Society.)

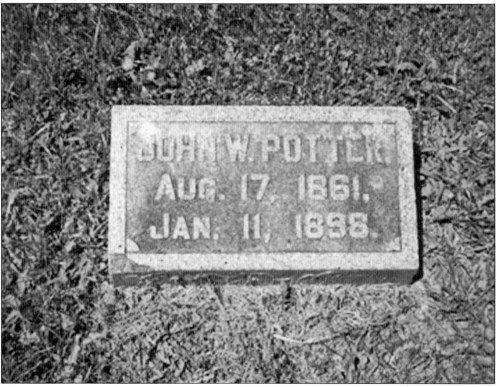

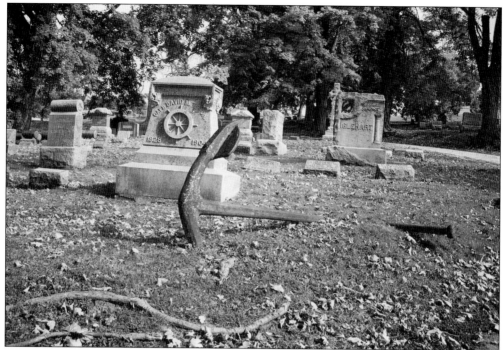

Capt. David A. Tipton lived in Harper House, but his life was the river. Captain Davey was a beloved figure in the community. He was in the pilothouse of the steamer *Colonel A. Mackenzie* when he died at the age of 78. The anchor at his grave, according to the *Town Crier*, was "dug out of [the Mississippi] River at Keokuk and was placed on the grave by Tipton's crew."

The rivers have always played an important role in the lives of Rock Islanders, especially during the 1800s, when transportation and trade depended on great rivers like the Mississippi. Capt. Andrew J. Whitney (1828–1869) was a steamboat captain who is remembered for saving his boat from wrecking during a storm. The anchor from his steamboat rests next to his grave.

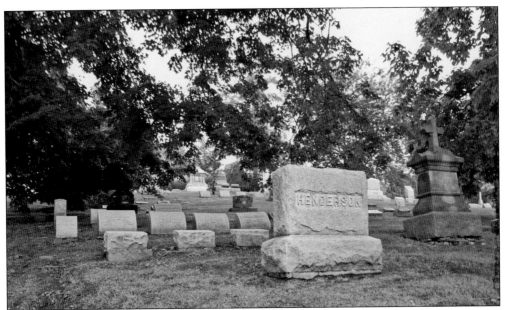

Capt. Marcus L. Henderson was a ferryboat operator. His last boat was the *Davenport*, and he sailed it between Rock Island and Davenport. In 1896, when he first worked on the river, the first government bridge across the Mississippi River was being constructed, so ferryboats were the only transportation between Illinois and Iowa. Captain Henderson was born in 1847 and died in 1926. He and his wife lived at the Harper Hotel.

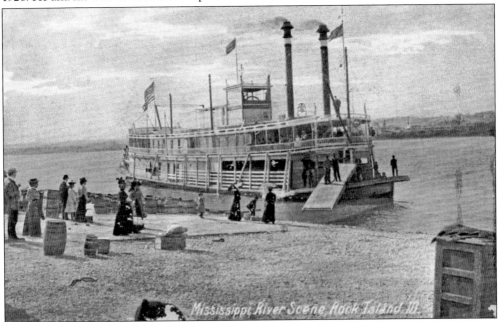

Though Col. George Davenport started the first ferry service in 1825 for his trading post, according to *A Q-C Century: Progress 99*, it was not until Capt. John Wilson founded the Rock Island-Davenport Ferry Company in 1837 that the ferry business boomed. The "best known of the old ferries was the W. J. Quinlan" (pictured here), a three-deck paddle-wheel steamer originally named the *Davenport*. Passengers paid a nickel per ride.

Kahlke Brothers Boatyard in Rock Island was established in 1863, and they were "builders of steamboats and barges, and river craft of every description," according to company letterhead. Peter Kahlke built a number of ferries, including the sternwheel ferry Davenport in 1904, which was later sold to William J. Quinlan, rebuilt in 1924 and renamed the W. J. Quinlan. Not just for commuting, the boat featured a live jazz band, slot machines, and a bar.

Born in Germany, Morris Rosenfield came to Rock Island in 1841 and started his career in the leather business. Eventually he founded the Moline Wagon Company (which made farm wagons and later was incorporated by John Deere). He cofounded the Hebrew Burying Ground Association and was called one of Rock Island's "best and most progressive citizens." He built his home where John Spencer's home once stood. It is now Coventry Apartments for older citizens. (Courtesy of Rock Island County Historical Society.)

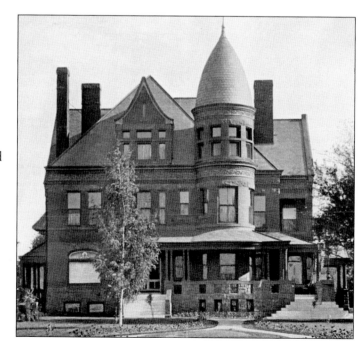

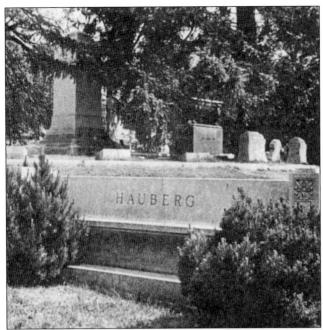

John H. Hauberg (1869–1955) was a life-long learner and adventure seeker. He practiced law from 1901 to 1914 but gave it up to travel the world with his wife, Susanne Denkmann. Marrying into the Denkmann and Weyerhaeuser empire, Hauberg eventually held executive positions with such companies as Weyerhaeuser and Denkmann Company, Rock Island Lumber Company, and Denkmann Paper Company. He founded the United Sunday School Boys Band, the Black Hawk Hiking Club, and Camp Hauberg. This is the Hauberg grave site in 1931. (Courtesy of Chippiannock Cemetery.)

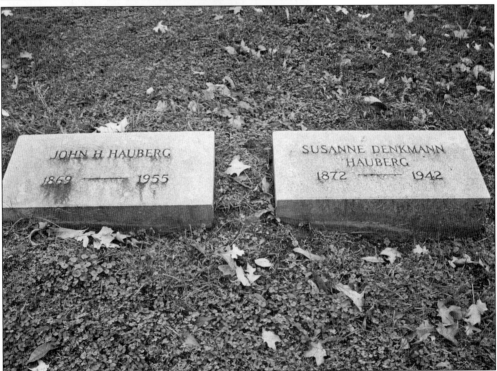

Though Susanne Denkmann Hauberg was from a wealthy family, she lived her life serving others. In 1909, she opened the West End Settlement House, which provided support for impoverished mothers and ill children. She assisted charities such as Bethany Home, Associated Charities, and the Woman's Club of Rock Island. In 1911, she married John Hauberg, who shared her passion for helping their community flourish.

Ever the nature enthusiast, John Hauberg was instrumental in creating Black Hawk State Park in 1927. He was also a prolific historian, writing extensively about Chief Black Hawk and interviewing various people in the community. His papers are housed in Augustana College's Special Collections Library. He was vice president of the Illinois State Historical Society, and he established the magazine *Illinois Junior Historian*, which is now called *Illinois History*. In 1940, he established the Indian Pow-Wow at Black Hawk State Park, inviting members of the Mesquakie tribes from Iowa and Oklahoma to take part. Among the guests in subsequent years was Mesquakie tribe member Mary Mack, Black Hawk's great-granddaughter (second from left). Hauberg is on the right. (Both courtesy of Rock Island County Historical Society.)

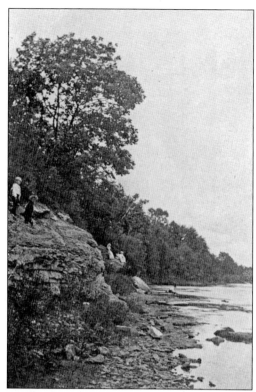

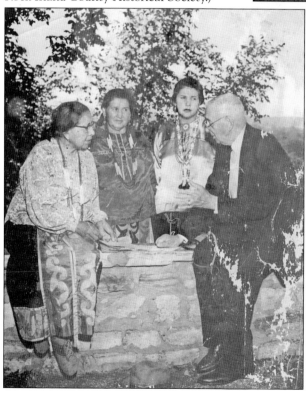

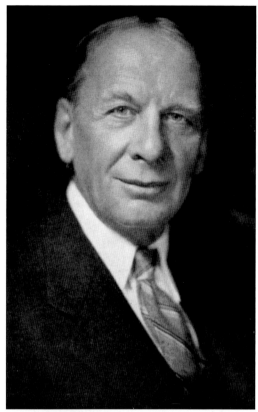

The John Hauberg Collection can be found in Augustana College's Special Collections Department, with items also at the Rock Island County Historical Society. Hauberg conducted more than 350 historical interviews with citizens of Rock Island County, and many were descendents of area pioneers. He is said to have "authored nearly 150 unpublished volumes of Rock Island County and Illinois history, typed and combined with photographs in binders." One of his subjects was Edwin Brashar (shown below, center, inspecting a broken gravestone in Dixon Pioneer Cemetery with Hauber, left, and Brashar's daughter, Mrs. Fanny Hunter). Brashar's uncle was pioneer Jonah Case. Hauberg published a number of historic articles as well. His collection is of enormous historical value to the local community as well as genealogists and historians the world over. The American Association for State and Local History presented Hauberg with the Award of Merit in 1953 for his historical writing contributions. (Both courtesy of Rock Island County Historical Society.)

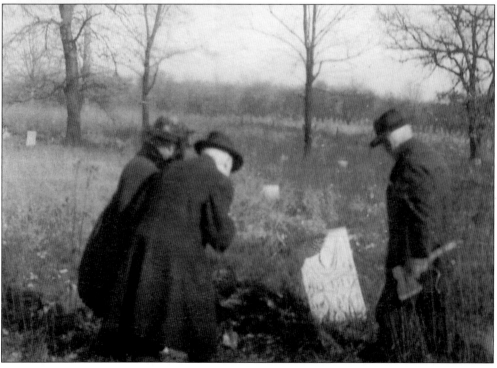

Charles Bishop Knox was born in Hampden, Massachussetts, in 1818 and came to Rock Island in 1841. He was originally a cabinetmaker. It was not long before he became the area's first undertaker and founded Knox Mortuary. He performed his first funeral in 1852; prior to that, friends of families would handle the ceremonial details. As he built coffins in his cabinet shop, there were often "looky-loos" who would peer inside his windows to watch—which led Knox to install screens to block his windows. (Courtesy of Rock Island County Historical Society.)

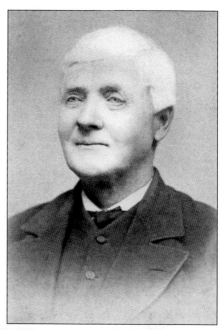

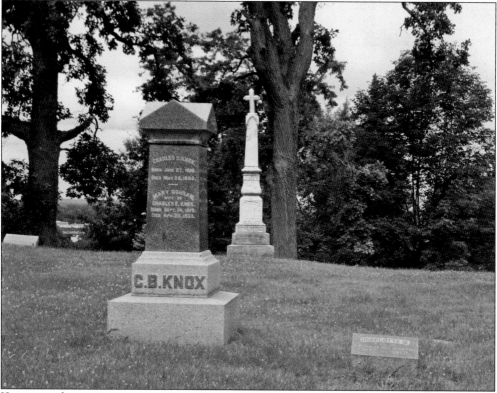

Knox served as county coroner, a supervisor, an alderman, one of the first captains of Rock Island's volunteer fire department, and was a three-term mayor. His son Benjamin Franklin "Frank" Knox, who was initially a grocer, followed in his father's footsteps and became one of the first licensed embalmers in the state. Son Harry T. Knox also became an undertaker.

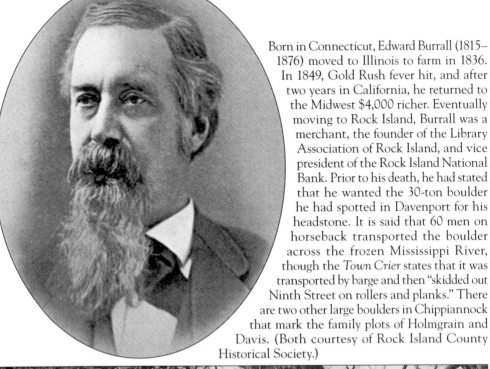

Born in Connecticut, Edward Burrall (1815–1876) moved to Illinois to farm in 1836. In 1849, Gold Rush fever hit, and after two years in California, he returned to the Midwest $4,000 richer. Eventually moving to Rock Island, Burrall was a merchant, the founder of the Library Association of Rock Island, and vice president of the Rock Island National Bank. Prior to his death, he had stated that he wanted the 30-ton boulder he had spotted in Davenport for his headstone. It is said that 60 men on horseback transported the boulder across the frozen Mississippi River, though the *Town Crier* states that it was transported by barge and then "skidded out Ninth Street on rollers and planks." There are two other large boulders in Chippiannock that mark the family plots of Holmgrain and Davis. (Both courtesy of Rock Island County Historical Society.)

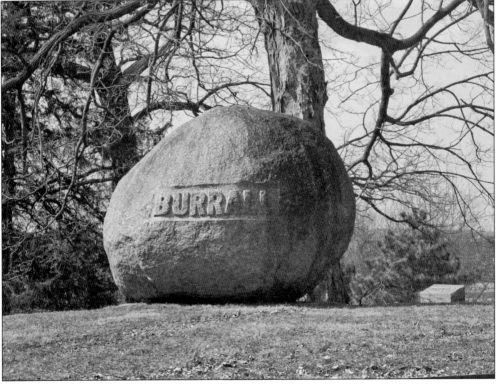

In 1899, A. D. Huesing Sr. founded A. D. Huesing Bottling Works (now A. D. Huesing Corporation), which eventually distributed Anheuser-Busch beer (1902), Pepsi-Cola (1935), Ocean Spray juices (1980s), and Lipton teas (1980s). After his father's death in 1930, A. D. "Bert" Huesing Jr. became president of the company. Bert acquired the Pepsi franchise, which led to major growth in distribution and for the company.

Frederick Boetje was a German immigrant who came to America to start his own business. After working for Weyerhaeuser and Denkmann for a time, Boetje started making his father's special recipe spicy mustard in 1889. He created the delicious condiment in his garage and sold it door-to-door with the help of his horse and cart. Boetje's Mustard is still sold today, and Boetje Foods, Inc. is located across Twelfth Street from Chippiannock.

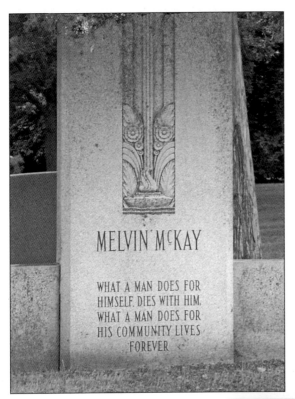

Melvin McKay was a philanthropist whose legacy lives on through the Mel McKay Charitable Trust. The trust has supported programs like the Bethany Home for Children and Families, the Putnam Museum, and the Quad Cities Red Cross. Mr. McKay's epitaph reads: "What a man does for himself dies with him. What a man does for his community lives forever."

Isaac Negus (1799–1883) became a leading businessman in Rock Island after he moved there in 1844. He felt the city had great promise and invested heartily in it, building a block of houses, Negus Hall, and his own home. According to *Biographical History of Rock Island*, Negus "was a man of whom it can be said that his own convictions took from in acts, and who, in his prosperity, helped those less fortunate than himself."

While most people called him "the Bug Man," the *Field Museum of Natural History Bulletin* called him a "brilliant self-taught scientist." Benjamin Dann Walsh was born in England in 1808 and came to Rock Island in 1850. For 19 years, he could be seen outdoors collecting insects and pinning them to his dunce cap lined with cork. Though it may have seemed strange, his passion for entomology earned him the position of state entomologist of Illinois. At the time of his death, his specimen collection numbered 30,000. Unfortunately his passion led to his demise. On November 12, 1869, Walsh was walking home from the post office along the train tracks. He was so entranced by the new specimen he had been sent that he did not realize the mistake he made until it was nearly too late. When he heard the train whistle, he jumped to the safety of the track next to him, when he should have remained where he was. He did not realize he had jumped into the path of the oncoming train. He dove off the track, but his left foot was crushed. Even after his foot was amputated, he joked at how helpful it would be to have a cork leg while collecting insects. Walsh died six days after the accident.

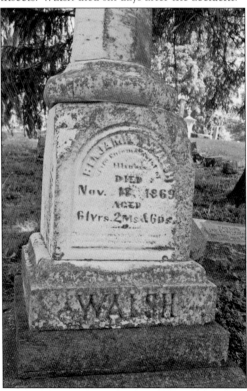

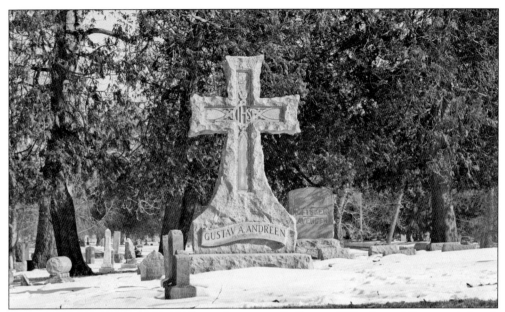

Gustav Andreen, Ph.D., (1864–1940) was Augustana College and Theological Seminary's fourth president from 1901 to 1935. The college was initially only for those of Lutheran faith, but Dr. Andreen made it the policy to welcome students of all faiths. One of the dormitories on the campus is named Andreen Hall in his honor. In 1910, Dr. Andreen was one of 10 American citizens honored by King Gustaf of Sweden.

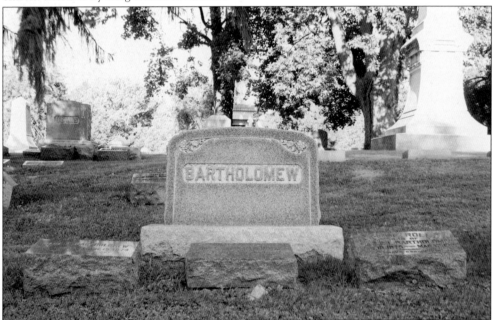

Edward Fry Bartholomew (1846–1946) was known by his initials—E. F. or Ph.D., D. D., or L. H. D. A well-known and beloved philosopher and teacher, Dr. Bartholomew was also known as the "Grand Old Man" of Augustana College. In 1888, he accepted the position of chair for the English literature and philosophy departments at the college, and he remained there for 44 years. He retired in 1932 but returned to teach occasionally. He was 100 years old when he died.

Four

WITH PRIDE AND HONOR
THE MILITARY

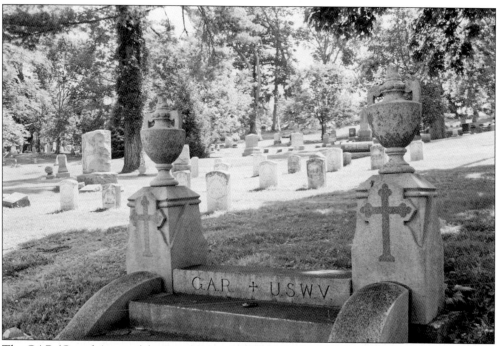

The GAR (Grand Army of the Republic) and USWV (United Spanish War Veterans) section of Chippiannock started out as John Buford Post #243 GAR. Half of the graves in this section are Civil War veterans, and the other half are Spanish-American War veterans. Later it became the Gustaf Lanoo Post. Now it is under the ownership of the Veterans of Foreign Wars #1303.

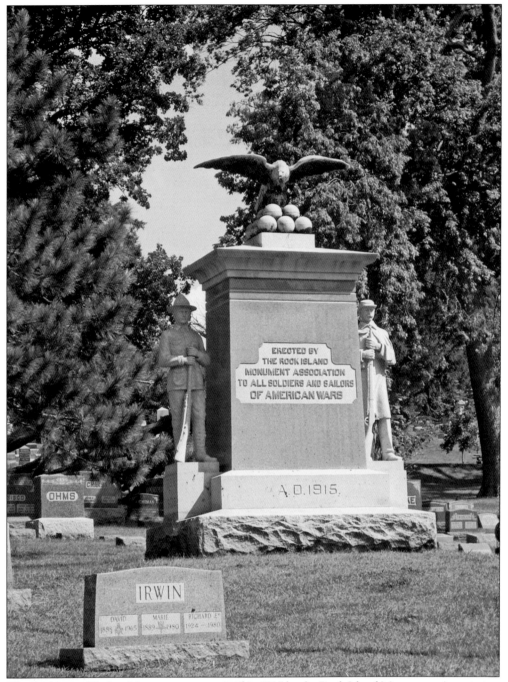

The Soldiers and Sailors Monument was erected in 1915 by the Rock Island Monument Association to honor all soldiers and sailors of the American wars. Soldiers and sailors are located throughout the cemetery, but this monument has the most prominent location on the grounds—it is the first monument seen upon entering the main gate.

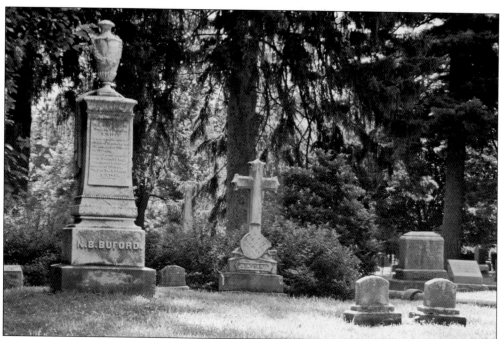

In Napoleon Bonapart Buford's family plot is a stately monument topped with an urn for mourning and a wreath for victory. The epitaph, though, is not for Napoleon but for his father, Col. John Buford. It reads: "Col. John Buford born in Virginia, A. D. 1779. He was a public spirited citizen of Kentucky for 41 years. He was 7 years a member of the Kentucky Legislature and 4 years a Senator of Illinois. Died at Rock Island, A. D. 1847." On the side of the monument is a brief epitaph for Maj. Gen. Napoleon Bonapart Buford. It reads: "Napoleon B. Buford. Born Woodford Co. Ky. Jan. 13, 1807. Died Chicago, Ill., Mar. 28, 1883." He played important roles in the Battle of Belmont, Missouri, and the Siege of Helena, Arkansas. According to the *Town Crier*, before the war he was president of the Rock Island and Peoria Railroad and founded the town of Andalusia. After the war, he became a special examiner for the Union Pacific Railroad.

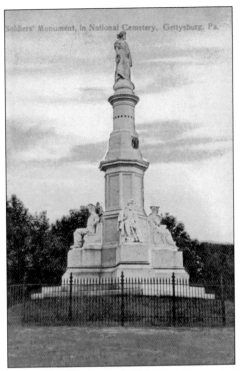

Half-brothers John Jr. and Napoleon Buford were distinguished Civil War generals. Both men attended West Point, which is where John Jr. is buried, according to the wishes of the soldiers under him who reportedly loved him like a father. This postcard features one of the many monuments placed around the battlefield at Gettysburg.

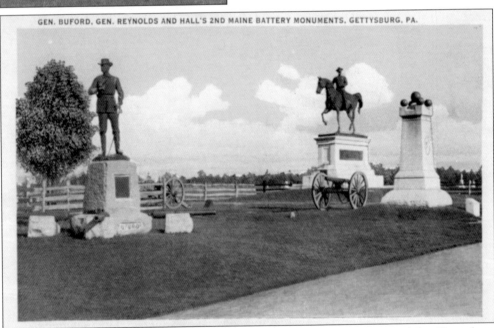

GEN. BUFORD, GEN. REYNOLDS AND HALL'S 2ND MAINE BATTERY MONUMENTS, GETTYSBURG, PA.

A monument in honor of John Buford stands at the northwest entrance of the Gettysburg battleground. It reads: "In memory of Major General John Buford, commanding the First division cavalry corps, Army of the Potomac, who with the first inspiration of a cavalry officer selected this battlefield July 1, 1863. From this crest was fired the opening gun of the battle." On one of the monument's cannons reads: "This is the opening gun of the battle, fired from this spot under the personal direction of General Buford."

Capt. Thomas Columbus Meatyard was an assistant adjutant general during the Civil War. Though not related to Gen. Napoleon Buford, he rests eternally in the Buford family plot. Meatyard was Buford's aid during the war, and they became close friends. After Meatyard's untimely death in 1868, Buford treated Thomas' wife, Marion, and young son, Thomas Buford, as if they were family.

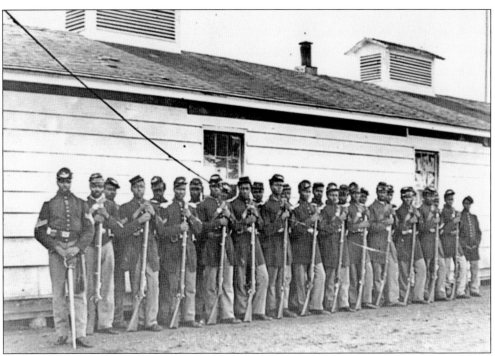

In the mid-1990s, Chippiannock staff member Tracey McVay was transcribing the handwritten ledgers of the grounds when she discovered the records of nine African American Civil War soldiers buried in unmarked graves in the cemetery. Chippiannock applied with the U.S. Department of Veterans Affairs to request military headstones for the men, which were placed in 2002. This photograph is of the 4th U.S. Colored Infantry, Company E, at Fort Lincoln. The author could not locate photographs of Chippiannock's soldiers. (Courtesy of B. A. Summers.)

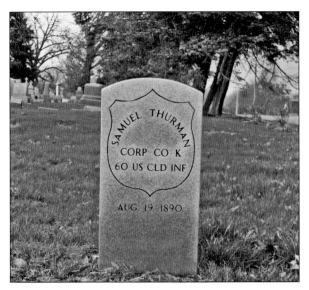

Once a slave in Mexico, Missouri, 21-year-old Samuel Thurman enlisted in the Union army—though his owner, Phillip Thurmand, received monetary compensation for him from the government. He was part of Company K of the 1st Iowa Colored Infantry in Mexico, Missouri, which later became the 60th Regiment of the U.S. Colored Infantry. The company took part in the battle at Big Creek (Wallace's Ferry) in Arkansas. While stationed at Helena, Arkansas, he suffered from exposure, which eventually led to his death in 1890 after he developed liver disease.

Napoleon Wood (spelled "Napleon" on his tombstone) was born in Barren, Kentucky, as a slave. After being drafted for one year, he enlisted when he was 22 and served in Company F of the 122nd Regiment of the U.S. Colored Infantry. Company F was stationed in Portsmouth, Virginia; was part of the siege of Petersburg and Richmond, Virginia; and eventually served in Texas. Wood died in 1888 of pneumonia complications from the lung disease he contracted while in service for his country.

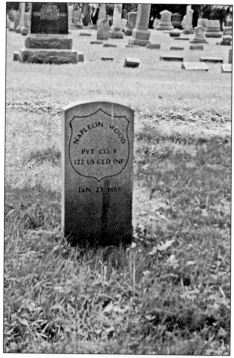

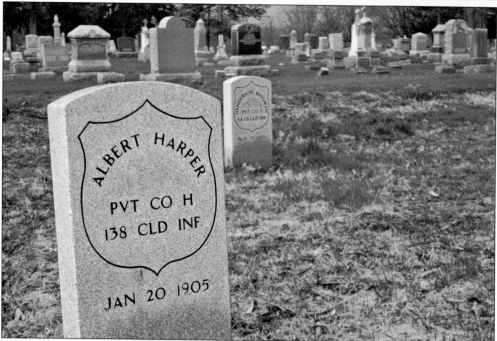

Though Albert Harper technically enlisted nearly three weeks after the Civil War ended, his regiment (Company H of the 138th) participated in scattered insurgencies in the South. Harper was 18 when he enlisted and became the Company H drummer. Later on, he married and had three children. Harper lived in Rock Island during the last five years of his life. Chippiannock Cemetery records state that he died of old age in 1905 when he was 63.

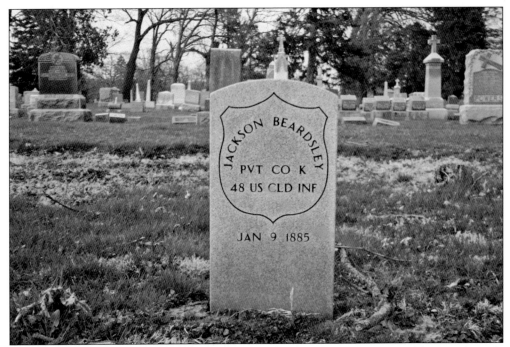

Of Chippiannock's nine African American Civil War veterans, Jackson Beardsley was the only known to have been injured in combat. While readying to shoot his own gun, his right hand was struck by enemy fire. Beardsley enlisted in the Union Army in 1863 at Camp McClelland in Davenport, Iowa—just across the river from Rock Island. After the war, he came back to live in Rock Island and was said to have great influence in the black community.

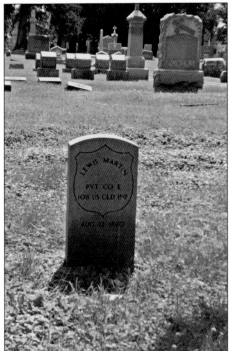

Lewis Martin was a slave born in Kentucky who became a soldier in the Civil War by enlisting. He was a member of Company E, 108th Regiment, U.S. Colored Infantry. He is one of the African American Civil War soldiers whose graves were discovered in the paupers' area of Chippiannock and recognized in 2002 during a special Memorial Day celebration.

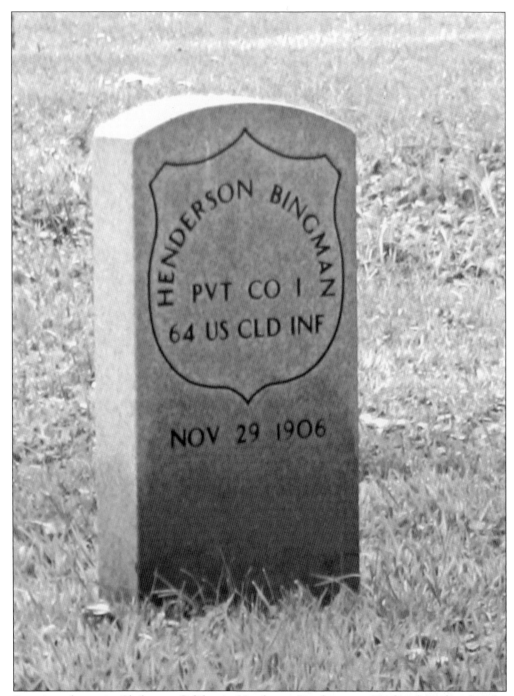

Born into slavery in Claiborne, California, Henderson Bingham was 31 when he enlisted in the U.S. Colored Infantry in 1864. He served in Company I of the 64th Regiment during the Civil War and was involved in battles at Ashwood Landing, Louisiana; Davis' Bend, Mississippi; and Point Pleasant, Ohio. In Point Pleasant, Private Bingham contracted measles, which affected his eyes for the rest of his life. He later married and had four children, dying in 1906.

Charles W. Hawes was born in 1841 in Rock Island back when it was still known as Stephenson. He was deputy sheriff of Rock Island when the Civil War began. He enlisted in Company A, 37th Illinois Infantry, Volunteers. In 1863, he was promoted to the rank of major for "meritorious service." He participated in the battles of Pea Ridge, Vicksburg, Morganzie Bend, and Yellow Bayou, among others.

William Hoffman was a Union brevet brigadier general in the Civil War. Born in 1807, he took part in almost every major American war during his lifetime. His obituary in the August 13, 1884, *New York Times* states that he "went through the Florida, Black Hawk and Louisiana wars. In 1846 he was engaged in mustering volunteers for service in the Mexican War." Later in life he was "promoted to Major-General and in 1872 he was placed on the retired list."

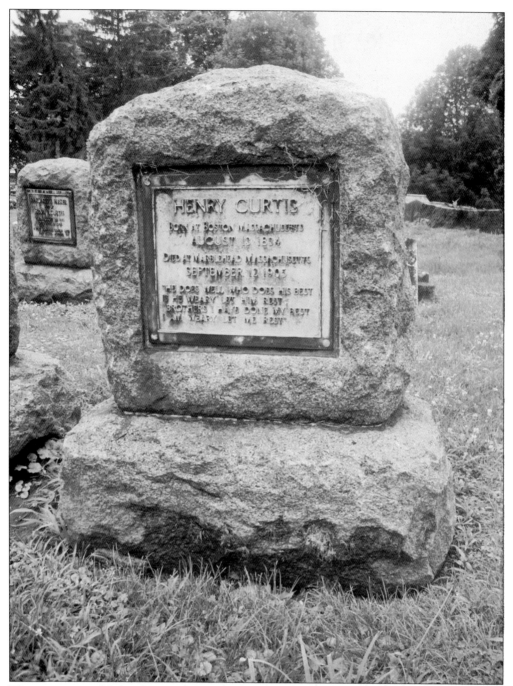

The gravestone of Colonel Henry Curtis reads: "Born at Boston, Massachusetts, August 13, 1834. Died at Marblehead, Massachusetts, September 12, 1905. 'He does well who does his best. Is he weary, let him rest. Brothers, I have done my best. I am weary, let me rest." He moved to Rock Island in 1856 and married Lucy Osborn, daughter of Marcus B. Osborn. He served in the Civil War, forming a company of volunteers with Major Charles Hawes.

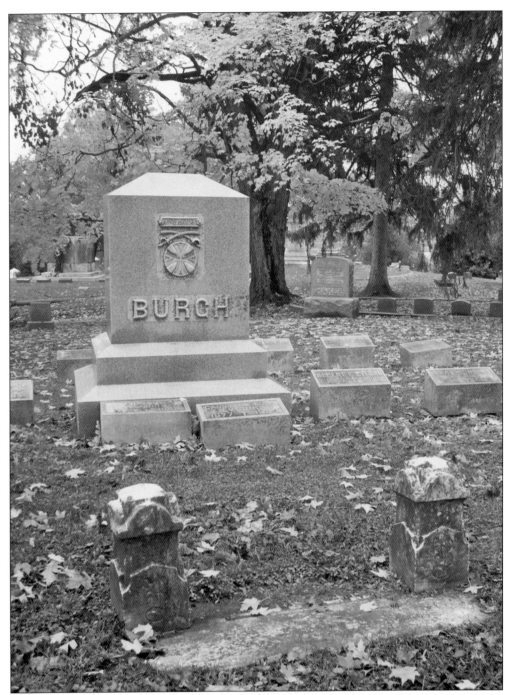

Born in 1833 in Liverpool, England, Col. Harry B. Burgh moved to the United States as a teenager and soon joined the army. He served on the frontier for a couple of years before he asked to be discharged. Burgh got married and lived a civilian life for about five years before the Civil War began. He enlisted and became the captain of Company A, 9th Cavalry Illinois Volunteers, which is carved on the family monument at Chippiannock.

Five

LOST LAMBS
THE CHILDREN

The Victorian era (1837–1901) was one of tremendous change. Advances in technology made for great strides in industry. There was a backlash against these advances though, because many felt that industry meant the loss of innocence and good values. Thus, the innocence of the child was greatly valued, and a general sentimentality was emerging. In the cemetery, this meant more personalized, sentimental gravestones.

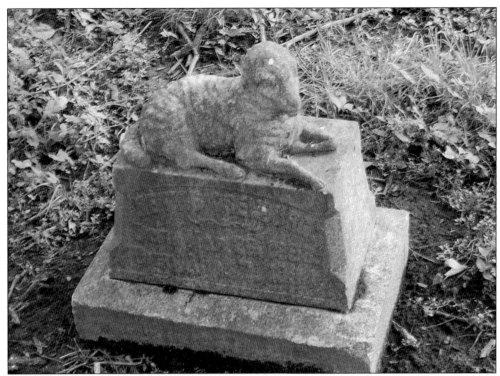

Because Victorian children were viewed as pure and innocent, the image of a lamb was a common motif in cemeteries. There are no less than three lifelike lamb monuments like this one at Chippiannock. Note the detail of the lamb's wool and features. This is the grave of young Albert Hugo, son of D. and L. Grotjan, born on November 3, 1885; died on January 9, 1887.

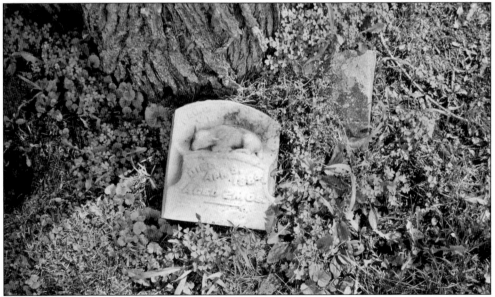

This small marble stone is located near the Infant Public Lot. It features a sleeping lamb, whose ears and tail are intact after more than 120 years since it was first carved. On the top of the stone is the name "Effie," and the inscription on the face reads "died Apr. 9, 1884, aged 2 mos."

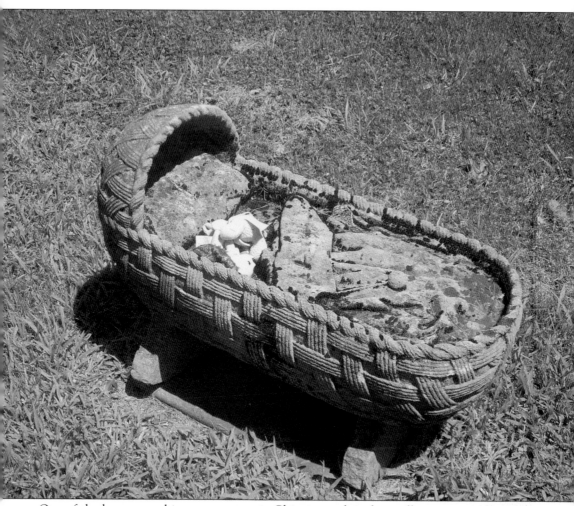

One of the heart-wrenching monuments in Chippiannock is the cradle gravestone for infant Jamie Sax (1886–1887) in the Rosenfield plot. The granite cradle was carved to look like a woven basket-style cradle. The detail, even after 100 years, is incredible. There is a blanket with "Jamie" carved into it, a rattle, and an indentation in the pillow where the baby's head would have rested. It is a rare occasion when there is not a toy left on or near Jamie's cradle.

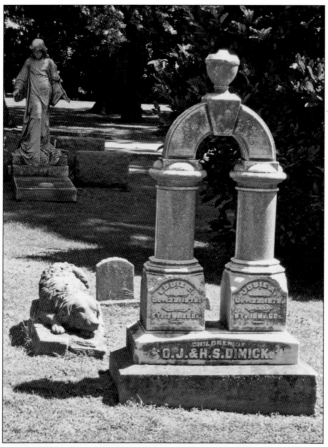

The most popular grave site in Chippiannock is undoubtedly that of the Dimick children, the youngest son and daughter of Otis J. and Harriet Dimick. The dog statue next to the graves of Josie, age nine, and Eddie, age five, has fascinated visitors for years. Josie, Eddie, and their dog (whom some locals refer to as "Rex") were inseparable, playing together every day. Unfortunately both children contracted diphtheria. Eddie and Josie died on the very same day, October 22, 1878.

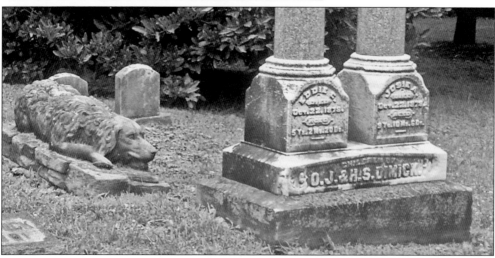

A faithful companion to the end, the dog followed the family to the cemetery for the funeral and continued to visit them every day for two years until his death. The Dimicks commissioned an artist in Chicago to create a statue depicting the Newfoundland and had it placed next to the children's graves. The dog, though, is not buried at Chippiannock. Flowers and sometimes toys (including dog toys) are often left at the children's graves and the dog's statue.

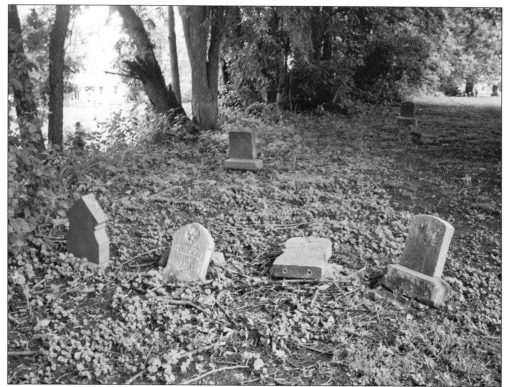

Babyland is how many people refer to a section of a cemetery reserved for children. Reading the markers in this area, one will find the graves of small children, infants, and stillbirths. Chippiannock has two Babylands, which are referred to as Infant Public Lots. The original location of the children's area is located on the south-central side of the grounds. The newer children's section is located on the top level in the center of the cemetery not far from the wooded area. The new area has a circular flower garden, two benches, and a statue of a girl holding a pitcher and flowers. It is called Jessica's Garden of Angels. One of the benches reads, "In memory of your babies." Superintendent Greg Vogele stated, "Annually Chippiannock donates our services to inter infants who were too young to require interment under the law. We do this to provide a place families can go to remember their child."

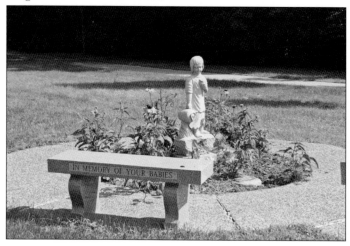

Fayette Grimes is buried in the Infant Public Lot, located in the south end of the cemetery. He was the son of J. W. and M. Grimes and was just nine days short of turning seven when he died on March 2, 1907. The flower below the epitaph seems to be a cinquefoil, which means "beloved child" in Victorian flower symbolism.

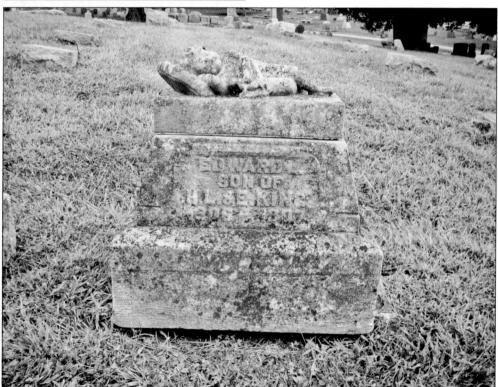

Little Edward King lived from 1906 to 1907. He was the son of H. L. and E. King. On his monument is a reclining child, resting his head on a pillow. One arm is under his head, and the other arm is reaching across his chest so that he can forever hold a beloved toy, a small rocking horse.

This beautiful wrought-iron cross stands sentry over the grave of an unknown infant. It was likely crafted by a blacksmith the baby's family would have known. There is no name or date on the cross. According to Spirit Design Online, "the tradition of wrought-iron cross cemetery art goes back to the 1600s in Austria and Bavaria. Blacksmiths in Tyrol and upper Austria made the first handcrafted iron cemetery crosses."

Maud Chinn was the only daughter of D. J. and Jennie M. Chinn; this is stated on her unique grave marker. Made of carved stone and piping, her marker is an interesting combination of professional and homemade work. Young Maud was born on August 14, 1875, and died on January 24, 1882. She is buried in the Infant Public Lot at Chippiannock. Her marker is on the south-central end of the cemetery, just east and down the slope from the main graves. Maud's father, D. J. Chinn, was a village clerk in Port Byron. Later he and his wife would move to Milan, Illinois, and Bettendorf, Iowa, before they moved out of state to New Mexico in summer 1906.

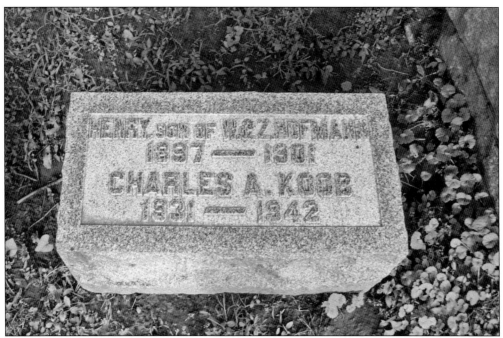

Charles Koob was 11 years old when he was electrocuted while playing with a downed power line. On November 19, 1942, the *Rock Island Argus* posted his obituary, stating that "seven tanks of oxygen were used and artificial respiration applied for nearly four hours," but to no avail. Charles's grandparents (Mr. and Mrs. William Hoffman Sr.) raised him after his mother died in 1937. Charles shares a gravestone with his uncle, Henry, who died at the age of four.

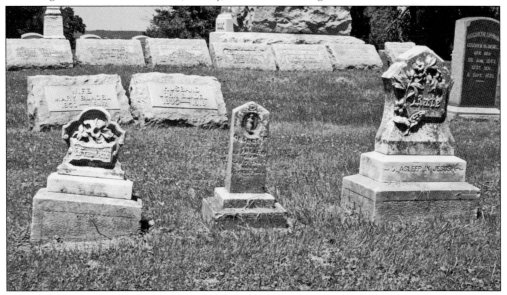

The children's graves in the Ainsworth/Bladel family plot are varied in their styles rather than identical like the adults' grave markers. The one on the left is for Frankie, and the epitaph reads: "Only sleeping." The flower is a morning glory, a symbol of the Resurrection. George's stone in the middle has an angel to watch over the child. The main flower on Kate's gravestone is a daffodil, which symbolizes rebirth or the Resurrection. The epitaph reads: "Asleep in Jesus."

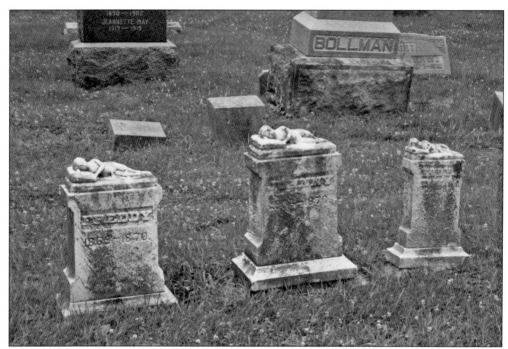

Some of the most ornate grave markers are those representing the lost children. The three matching markers shown here, differentiated only by size, are for (from left to right) Freddy (1868–1870), Johnny (1866–1870), and Eddy (1872–1872). Aside from the children's names and dates, no epitaph can be seen on the front or back—not even the boys' surnames. The markers do not seem to be part of a family plot. Cemetery records state that Frederick William Caughey's lot is owned by Weyerhaeuser, Denkmann, and Bladel and that he died of scarlet fever (as did John P. Caughey). Hugh Edward Caughey was only five days old when he died; this lot was owned by Frederick Weyerhaeuser, and it was sold to Hugh Caughey. All three boys died in Coal Valley. Each child is draped with a gossamer swathe, and each tiny head rests on a pillow. The figures are without traditional clothing, to allude to their innocence. The nose and eyes are still visible on Freddy's monument. The details of the hand resting on the pillow are still visible.

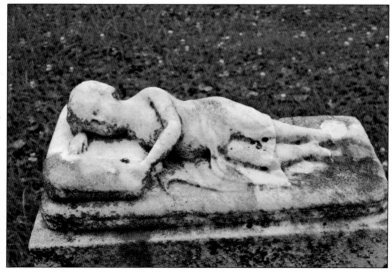

Ralph H. Tanner was only five months and two days old when he died on July 15, 1885. His grave marker is an example of one constructed of mixed materials—in this case, a brick pipe base and a metal ornamental piece shaped almost like a lollipop. Perhaps the marker was created by a relative who was a blacksmith or a brick maker. It was not uncommon for poor families to create their loved ones' grave markers. Often they would use whatever materials were readily available. Wooden markers were sometimes used but would fall apart with time. Metal markers had longevity, though they could be victims of theft for scrap metal.

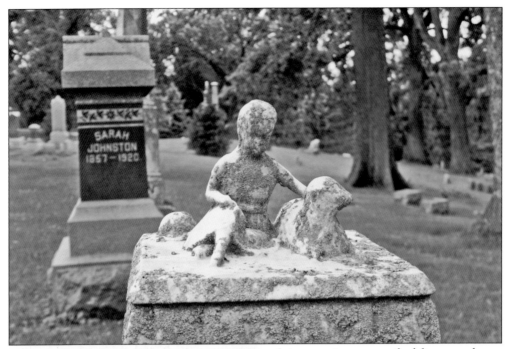

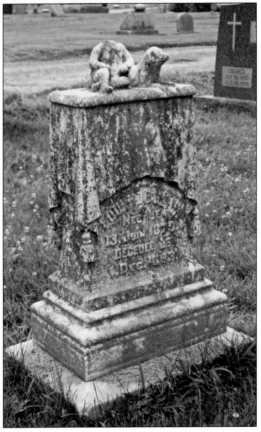

It is a rare instance to find figures such as these where the little girl's or boy's head is intact, likely because their necks were so delicate, and time wore them thin. Shown here on the monument for the Johnston children is a girl in a dress sitting with her legs crossed. She had her arm around a lamb, and her sun hat sits behind her to the left (on close inspection, one can see the ribbon around the hat). Though the girl is moss-covered, her dress still has some detail, such as eyelet trim. While the decor is clearly feminine, interestingly enough, the epitaph on the front of the stone is for "Barry Don Johnston, son of Jas. (James) & Kate E. Johnston" who was born in 1879 and lived just under two years. The gravestone for a little boy named Louis (leaning against a lamb) lost his head years ago. This marker is located just inside Old Calvary Cemetery, east of Chippiannock's border.

Six

LOST SOULS
THE NOTORIOUS

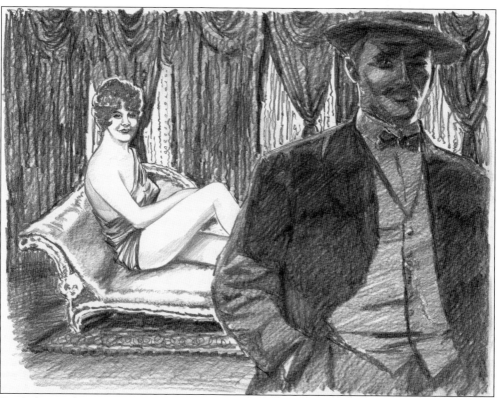

Brothels, speakeasies, murder, and mayhem are a part of the gangster life. When most people think of Midwest gangsters, Chicago's Al Capone comes to mind, but Rock Island had its own underworld of debauchery, led by the notorious John Looney. Looney was involved in gambling circuits, prostitution, extortion, and up to 15 murders. He was eventually found guilty of murdering William Gable in 1922. Paul Newman played a character based on Looney in the film *Road to Perdition*. (Original art courtesy of Bill Doulas.)

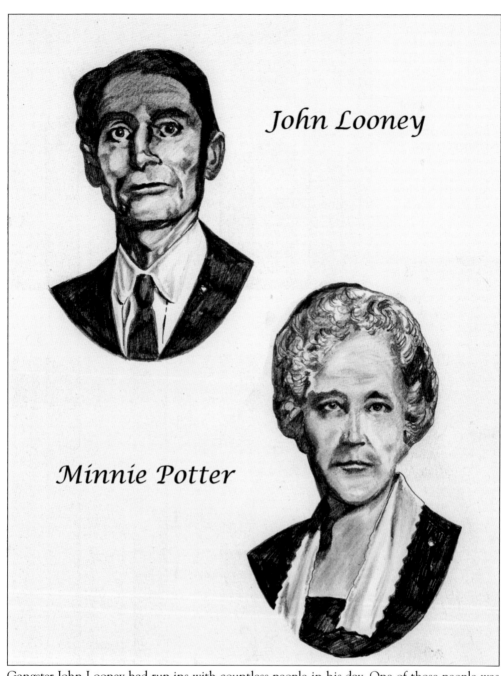

John Looney

Minnie Potter

Gangster John Looney had run-ins with countless people in his day. One of those people was Minnie Potter, editor of the *Rock Island Argus*, with whom he battled weekly in his scandalous newspaper, the *Rock Island News*. Disliking how Potter's paper sought to tell the truth about Looney's illegal ways, he reported that Potter was "insane, syphilitic" and was having various affairs. Potter responded by exposing him for the criminal he was. (Original art courtesy of Bill Douglas.)

During Prohibition, John Looney made sure his friends (whom he charged steeply) were kept with liquor and protected from the authorities by his lieutenants and other lackeys. Those not under his protection were subject to raids. This image shows barrels of confiscated booze from an unknown location. (Courtesy of B. A. Summers.)

A two-term Rock Island mayor, Harry Schriver was best known for his violent feuds with gangster John Looney. The *New York Times* reported on March 27, 1912, on a riot outside the Rock Island police station after Schriver "badly beat" Looney. Though he had libeled Schriver in his scandalous newspaper (stating Schriver frequented saloons and brothels), Looney had many supporters—who were responsible for two nights of rioting. The police were forced to open fire. Two people died and nine were severely injured.

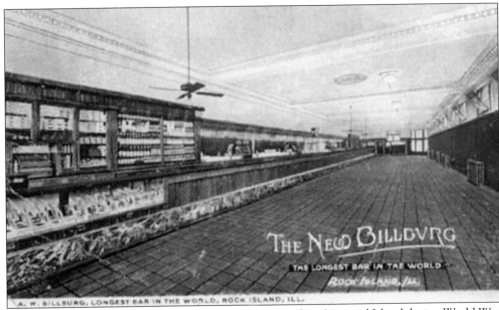

A. W. BILLBURG, LONGEST BAR IN THE WORLD, ROCK ISLAND, ILL.

When the federal government closed all bars within 3 miles of Arsenal Island during World War I, the New Billburg Bar went from a popular, respectful establishment to a den of iniquity. This continued after the war due to Prohibition. Anthony Billburg, who was a friend of gangster John Looney, became one of his lieutenants and was kept with a very expensive supply of liquor for his speakeasy. Before long, Billburg and other Looney cronies fed up with his racket ambushed Looney on Market Square. But instead of killing John Looney, Billburg killed Looney's son, Connor. He spent 20 years in prison for the crime, even though the famous Clarence Darrow was his attorney. Anthony's wife, the ever-resourceful Margaret Billburg (buried in an unmarked grave next to the Alexanders) started her own business out of the bar to make ends meet. She became a madam—though she welcomed the Salvation Army into the bar to hold Sunday services. Margaret and her girls were only arrested once for their work. Her employees were fined $15 each while she was fined $5.

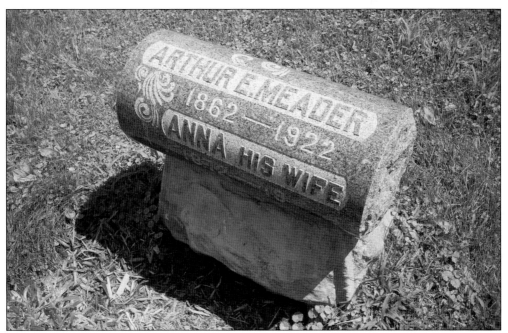

Arthur Meader (1862–1922) led a double life. To most, he was the mild-mannered manager at the Illinois Life Insurance Company. To the Rock Island underworld, he was a man with a gambling problem—someone whose life equaled his death. On January 9, 1922, Meader arrived at work in the Best Building downtown but left through the fifth story window. Of the 12 murders linked to John Looney in 1922, Meader's was the first.

John Looney's son, John Connor Looney (known as Connor), was gunned down in front of the Sherman Hotel in downtown Rock Island near Market Square on October 6, 1922. The hotel is no longer in existence, and its location is now a parking lot.

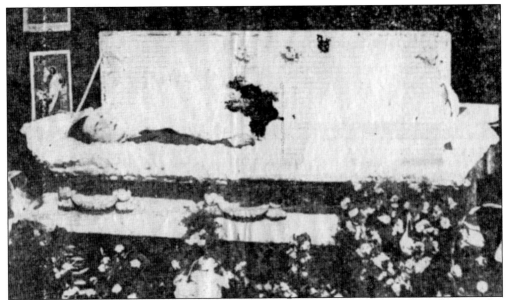

This photograph of Connor Looney in his casket was printed on the front page of John Looney's newspaper, the *Rock Island News*. Looney proclaimed that the *Rock Island Argus* was involved with his son's death, as he had a long-standing battle with the rival paper. Anthony Billburg of the New Billburg Bar, though, was found guilty of the murder and sentenced to 20 years in prison. (Courtesy of Rock Island County Historical Society.)

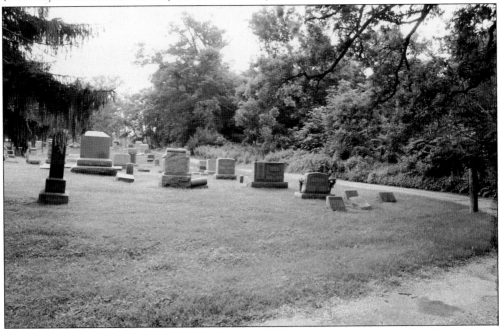

Connor Looney is buried in an unmarked grave in Old Calvary Cemetery, which is located next to Chippiannock grounds. Connor's mother, Nora (née O'Connor), is buried next to him; her grave is also unmarked. His father, John Looney, is buried in Rose Lawn Cemetery in McAllen, Texas. The staff of Chippiannock cares for Old Calvary Cemetery and Calvary Cemetery, which is across Thirty-first Avenue from Chippiannock.

Jeweler Jacob Ramser was one of the few people who was not afraid of John Looney. After Looney used the *Rock Island News* to libel Ramser's sister, Dina (the Rock Island police matron), he got into a heated argument with Ramser at a barbershop. Looney drew a gun. Ramser grabbed it from him and got shot in the hand in the process. Still not backing down, Ramser beat Looney and would have shot him if the safety had not been on.

A former letter carrier, John Scott was an upstanding citizen until he started investigating one of John Looney's cronies—who happened to be police Chief Thomas Cox. The *Institution Quarterly* reported in 1920 that Cox had the "reputation of being one of the 'best thief catchers' in the state of Illinois" and reported that there were fewer arrests since the year before. Likely he was protecting the illegal operations and operators instead of arresting them. Scott was nearly disbarred after getting involved but eventually salvaged his reputation.

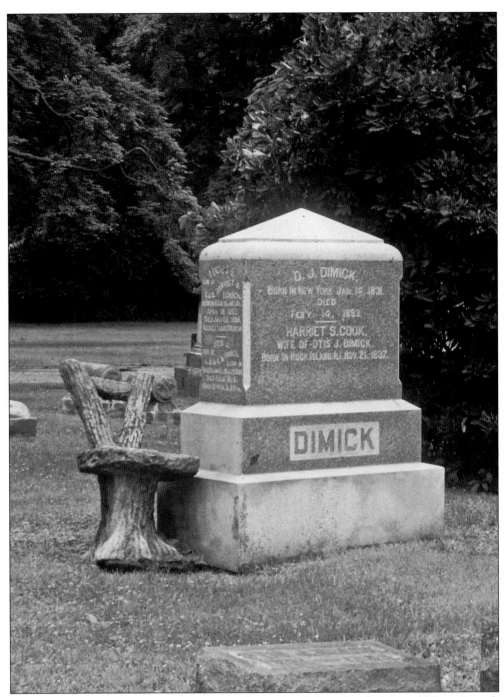

The darlings of Chippiannock, Eddie and Josie, had a black sheep brother named Lucius Dimick. Business- and responsibility-challenged, Lucius married Lizzie Beecher but had mistresses and visited the Toboggan Slide brothel. The October 12, 1889, issue of the *Rock Island Union* reported on the trial of Elizabeth "Lizzie" Dimick, who was "charged with manslaughter in the shooting of her late husband." Lizzie went to the brothel at 117 Nineteenth Street, called him a "dirty pup," and shot him. Lucius' father, Otis, bailed her out, and she was acquitted due to a hung jury.

Called "the mad butcher of Milan," Henry Bastian's notoriety was even covered in the *New York Times* on April 5, 1896. Bastian was a farmer who lived outside Milan. It stated that Bastian "killed three men in his employ [and] that he fed their bodies to his hogs." It is believed that he killed up to five hired men and one "colored woman" before he had to pay them. "Among other startling disclosures," read the paper, "is the unearthing of a hip bone near the chicken coop . . . [and] a portion of a human skull." He hung himself in the barn when the authorities were on to him. Bastian's grave is unmarked. One of his victims, John Lauderbach, is also buried in Chippiannock in an unmarked grave, which is located in the South Public Lot, where individual graves were sold rather than full family plots. His other known victims include Fritz Kuschman and Marshal Lewis, both of whom disappeared in 1894. Bastian was 27 years old.

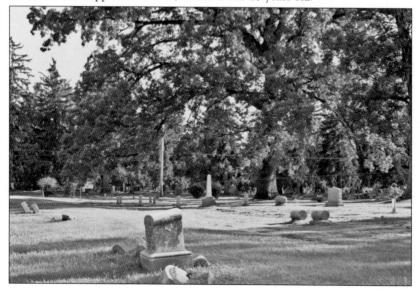

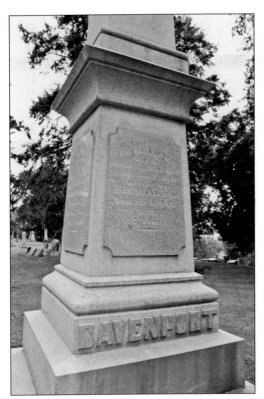

Col. George Davenport was murdered in his home on Rock Island Arsenal on July 4, 1845. "Robbery was the objective—murder the means," stated the *Davenport Gazette*. He was "our oldest and most wealthy citizen." Attacked in the early afternoon, Davenport died that night after relaying the details of the violence that ensued. He was shot, repeatedly choked, and dragged through the house (to open the safe). It is believed three to six men were involved in the crime.

Before he became the Honorable Samuel S. Guyer, he was a lawyer appointed to defend the Redding brothers, William and George, during Col. George Davenport's murder trial. The Reddings were charged as accessories; William Redding served one year, and the charges against George were dropped. (Courtesy of Rock Island County Historical Society.)

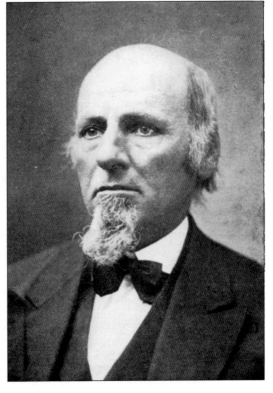

Those arrested for the murder of Colonel Davenport included William Fox, Robert Burch, John Long, Aaron Long, William and George Redding (father and son), Granville Young, and John Baxter. On the gallows, John Long admitted his guilt and "stated the true murderers of Col. Davenport to be Robert Burch, William Fox, Theodore Brown and himself." He proclaimed his brother and Young were innocent. All three were hanged anyway—Aaron twice, for the rope broke—and their bodies donated for dissection purposes. Later the skeleton of John Long was displayed on the Rock Island Arsenal in the hospital steward's office for years. It eventually made its way to the Rock Island County Courthouse, the Hauberg Museum at Black Hawk State Park (above), and was finally buried in Dickson Pioneer Cemetery (shown below) in Rock Island in 1978. Fox escaped before his trial and disappeared. Burch was sentenced to life in prison; he escaped but was caught and killed.

Dr. Cyrus Foster was a distinguished physician and surgeon whose life ended in murder. In October 1924, after Dr. Foster had walked his sister-in-law home and was returning to his own, two men jumped him. He was shot in the side and left for dead, shouting, "Murder! Murder!" Though a Peoria man called "Peaches" Kinney was arrested for the crime, no one was prosecuted. Foster was a physician to the poor in the early 1900s and was appointed Rock Island health commissioner in 1918. In August 1918, Foster recommended that water from cisterns (underground water reservoirs like this one shown here) not be used due to contamination and risk of typhoid fever. At the end of that year, he also repealed a ruling that did not allow dancing during the recent Spanish influenza outbreak. He will forever be known for his mysterious end, though.

Seven

MAJESTIC MONUMENTS
SYMBOLS IN THE CEMETERY

The monuments at Chippiannock Cemetery are truly magnificent. Whether larger-than-life or petite and simple, each monument tells the story of someone who lived and was loved. In many cases, these memorials are the only memories left behind, as families would move or descendents would also pass away. Dr. St. Elmo Morgan Sala had a practice in Rock Island and was also the city's health commissioner in 1895.

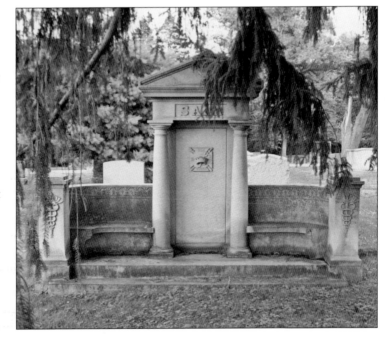

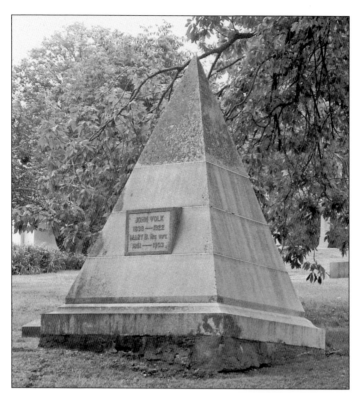

The Midwest may seem an odd location for an Egyptian monument, but Chippiannock does indeed have its own pyramid. At the grave of John and Mary Volk rests a granite pyramid. John Volk was a contractor and builder who constructed many residences in Rock Island, as well as 400 depots for the Rock Island Lines railroad and other buildings in the Midwest.

The obelisk, from the Greek word "obeliskos" meaning "needle," is an ancient Egyptian symbol. It represents a ray of sun, which first fell on the sun god, Ra. According to the Association for Gravestone Studies, obelisks were popular monuments, which were "considered to be tasteful, with pure uplifting lines, associated with ancient greatness, patriotic, [and] able to be used in relatively small spaces." Pictured here is the Fries monument in 1931. (Courtesy of Chippiannock Cemetery Heritage Foundation.)

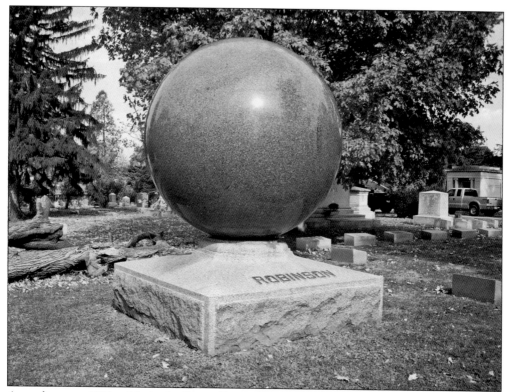

According to a 1975 article in the *Focus*, "Legend has it that Dean Tyler Robinson saw this more than 6-ton polished granite ball at the first Chicago World's Fair and selected it as his grave marker. It is pinned to the 6-ton base on which it rests." His wife, Julia Spencer Robinson, was the daughter of Judge John and Eliza Spencer, who were wealthy and well-respected Rock Island pioneers.

The Kolls monument is an example of white bronze. White bronze is actually made of zinc and is recognizable by its bluish-gray tint. Although white bronze was available from a number of sales locations across the United States (1870s to 1912), all of the monuments originated in Bridgeport, Connecticut, where they were manufactured. People custom-ordered each monument by selecting the style of the marker and symbols they wanted.

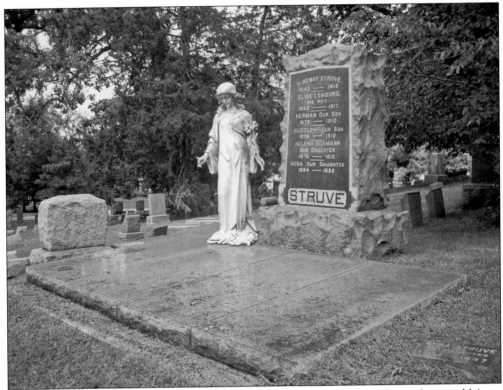

The Struve family plot features a stunning, life-size mourning woman (carved in marble), an impressive upright monument in rough-hewn red granite, and a large, four-piece slab of dark gray granite. Below the slab is an underground mausoleum, where the family members are interred. At one time, steps went down to the mausoleum doors. The mourning woman holds a stem of lilies and the blossom of one flower in her other hand.

William Hickman Harte was a naval officer who was killed during the Civil War on the U.S. gunboat *Mound City* while battling the Confederates in Arkansas. The large Celtic cross memorial near the office is dedicated to him, though he is not buried in Chippiannock, and his wife, Mary Ann Betty. The cross was sculpted by artist Alexander Stirling Calder. Mary is buried with the Betty family at the top of the bluff.

The gravestone of husband and wife John and Bessie Ash is unique in that it has full memorial carvings on both sides of the stone—a rare practice for stones carved in the 19th century. On John's side is the symbol of the broken column, which represents the death of the family patriarch. On Bessie's side are hands clasped in matrimony. The word *farewell* can be read on the carved ribbon above the hands and *in memory of* is below them. John died on February 15, 1868, at the age of 64. Bessie died on October 3, 1865, at the age of 67. The Ash monument was nearly pushed over during the July 21, 2008, storm when a tree near it blew down. The tree fell backward, ripping its roots out of the ground, and nearly pulled up the Ash gravestone.

D. F. Kinney was a horticulturist and nursery owner. He was secretary for the Department of Agriculture of the State of Illinois, Rock Island County, in 1859 and 1860. The unique bathtub-like coping for his grave likely would have been filled with planted flowers, which would have been a fitting memorial for Kinney.

The grave of Charles Buford Jr. is marked by a cross carved to look like it was made of tree branches. The cross is a Christian symbol of faith. The severed branches represent mortality and recall nature. The ivy climbing up the cross represents memory, faithfulness, and undying affection. Charles is the son of Charles and Lucy Buford. The epitaph on the stone is simple: "In memoriam. Charles Buford, Jr. Requiescat in pace."

This gravestone is for a girl named Maria who died at the age of 10. The carving of the hand is holding a bouquet of flowers (condolences and grief). On close inspection, the sleeve is feminine, which may symbolize a mother's grief.

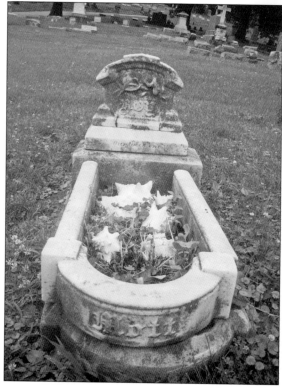

Lilies can mean resurrection or purity. Since this is the grave of a child, the lily on the headstone would likely represent purity. The epitaph is simple; the child's name ("Roy" on the headstone and "Mott" on the foot of the bed) and "Our loved one." The shells are probably decorative. In Buddhism, the conch shell is one of the Eight Auspicious Symbols, the original horn-trumpet used to awaken one from the slumber of ignorance.

Hans Einfeldt died at age 47. A freak accident took his life at the carpentry shop where he worked when a small piece of wood flew out of a machine and struck his head, killing him. A small dog rests at his grave. The dog was likely a beloved pet. Symbolically, the dog represents loyalty and that the deceased was worthy of being loved.

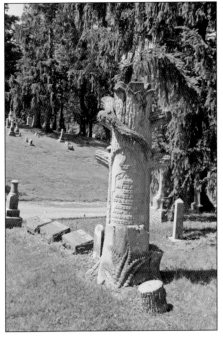

According to Douglas Keister's *Stories in Stone*, treestones were popular from the 1880s to approximately 1905. Treestones were made of limestone and were often used to mark the graves of Woodmen of America. B. F. Craig, who was born May 26, 1831, died on March 23, 1892. He was in Company B, 8th Iowa Infantry. He was a member of the Independent Order of Odd Fellows.

The Fitzpatrick marker is limestone and has been carved into the likeness of a rugged wood planter on a stack of stones. John Fitzpatrick's name is carved in the top piece, which is also a planter. His wife's name is carved around the section below the planter ("his wife" is written on this side), and the date of death (presumably John's) is below that on the stones. It reads, "Died Sept. 21, 1905."

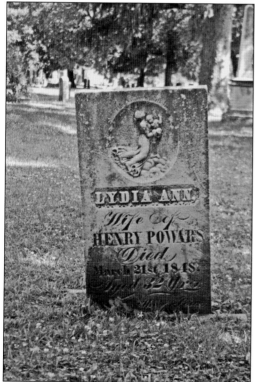

Lydia Ann Powars was only 32 years old when she died of lung fever in 1948. Near the base of the gravestone is an epitaph for her son, Benjamin Franklin. According to *150 Years of Epitaphs*, Benjamin died at the age of six months. Note the artistry of this fine stone—the detail of both faces, the fabric of the shirt, the clouds, and Godly rays shining down toward the figures.

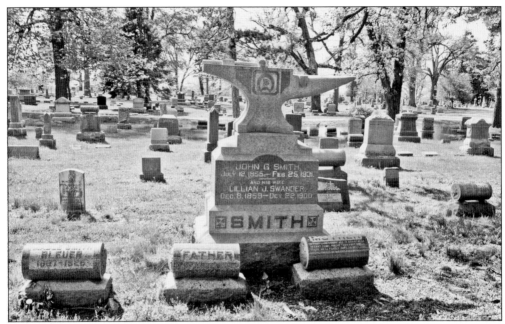

There are three carved granite anvils at Chippiannock Cemetery, and each one represents a blacksmith. John G. Smith (monument shown here) has a monument that is very similar to that of William Tenges' anvil stone. Smith's monument was carved from red granite and reads: "John G. Smith, July 12, 1855–Feb. 25, 1931. And his wife, Lillian J. Swander, Dec. 8, 1859–Oct. 22, 1900." The third anvil belongs to August Sehnert.

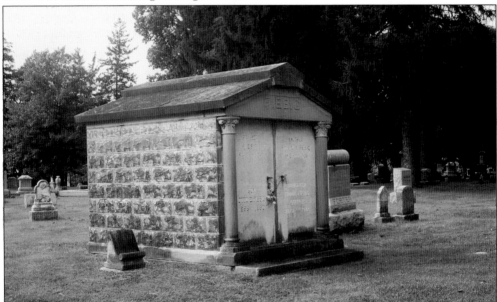

The Fiebig mausoleum contains the remains of father Charles, mother Mary, son Otto, and daughter Emma Cooper. According to *150 Years of Epitaphs*, Charles Fiebig was considered "the best safecracker west of Chicago" and "opened over 500 safes without knowing the combination." He also owned his own shop where he made and repaired burglar alarms and clocks. The Fiebig mausoleum has an interesting combination of rough-hewn bricks, unornamented tomb panels, and Corinthian columns.

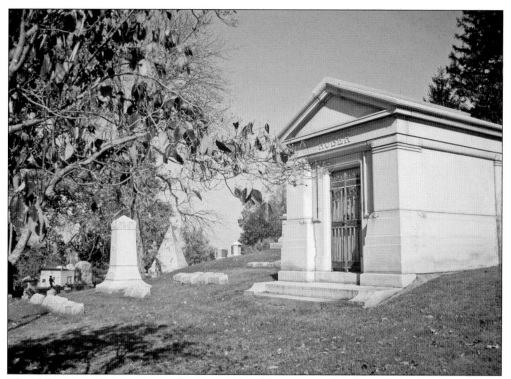

The Huber mausoleum is an excellent example of classic revival architecture, which is "the most common type of cemetery architecture," according to *Stories in Stone* by Douglas Keister. It is located slightly northeast of the cemetery's office and main gate. Ignatz Huber emigrated from Bavaria to America in 1849 and eventually owned his owned beer brewery, which later became the Rock Island Brewing Company.

This angel is forever in prayer beside the grave of Peter (1833–1920) and Sarah Elizabeth King (1847–1912). Angels are God's messengers, and they are also guardians. Two Biblical angels who are often represented in cemeteries are Gabriel and Michael. Gabriel can be spotted holding a horn, and Michael carries a sword. Most angels in cemeteries have no specific identity and are viewed as protectors of the dead, standing sentinel over the graves.

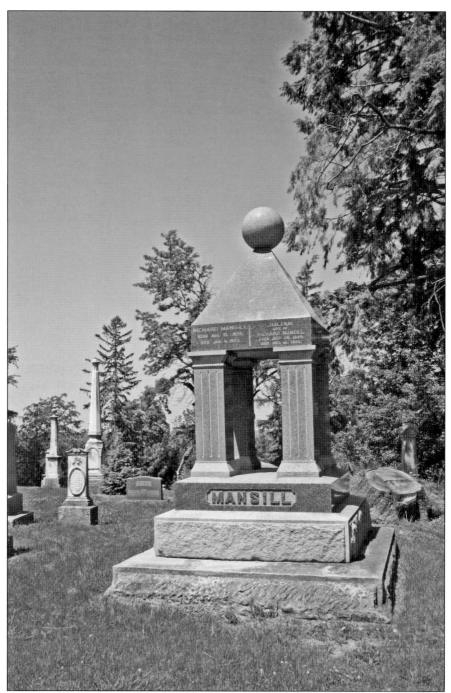

Richard Mansill not only has arguably the most unique monument in Chippiannock (he designed it himself), but he was also a unique thinker. When he came to Rock Island as an English immigrant, he started working in a coal mine. Eventually he organized his own mining company. Mansill was also interested in the sciences—geology, natural science, and astronomy. He published *Mansill's Almanac: Planetary Meteorology, Weather Forecaster's Guide, and New System of Science* from 1857 to 1901.

Eight

STORM OF THE CENTURY
THE STORM OF JULY 2008

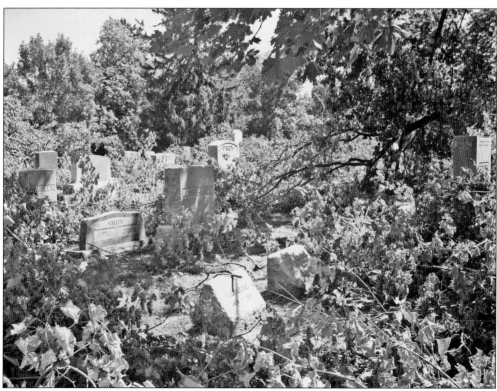

On July 21, 2008, a derecho (a high-wind and widespread windstorm) hit the Quad Cities and knocked out power for more than five days in some areas. One of the hardest hit areas was Chippiannock and its sister cemetery, Calvary Cemetery. The giant persimmon tree near the entrance to Chippiannock was split into three sections—two of which crashed to the ground.

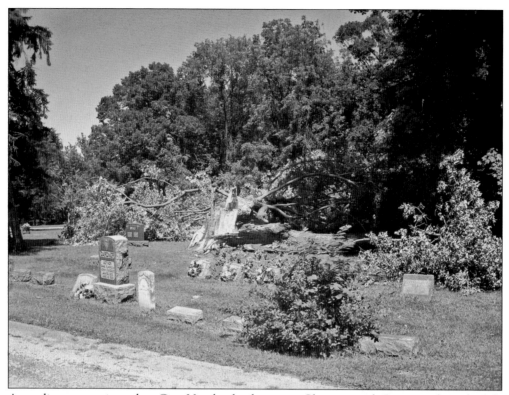

According to superintendent Greg Vogele, the damage at Chippiannock Cemetery from the July 21, 2008 derecho, totaled nearly $98,000, which is approximately the cemetery's entire annual budget. Staff members worked long hours and volunteers from the community assisted on clean-up days, but it took months—if not more than a year—for the cemetery to return to its original state. Donations poured in—to the tune of $36,000—to the Chippiannock Cemetery Heritage Foundation by individuals.

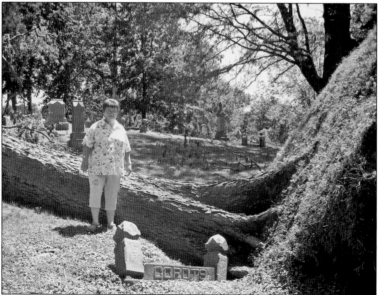

To give an idea of just how huge one of the fallen trees was, Cindy Powers, the author's mother, stands near the base of the hackberry. The root ball alone was 10 feet across in diameter. This tree was approximately 150 years old.

The Reimers mausoleum is located on the north side of Chippiannock. So many branches covered the ground and monuments in that area after the July 21, 2008, windstorm that many visitors said it looked like a war zone. The north side of the cemetery was the hardest hit. What was once a shady lane is now wide open to the sky.

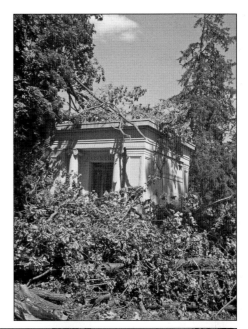

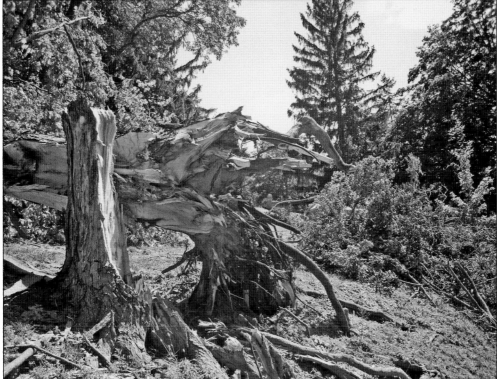

As reported in the *Quad-City Times* on July 21, 2009, Chippiannock's superintendent Greg Vogele "had seen a lot of storm damage in his time, but nothing prepared him for what he witnessed the morning of July 21, 2008." The storm was far from selective, knocking down recently planted trees as well as 200-year-old oaks with over 80-mph winds. The *Times* reported that the storm caused millions of dollars in damage to the Quad City area.

If there is one thing the storm of 2008 taught the Quad City community, it is that no matter how well cared for, no cemetery is eternal. Nature can be harsh and unpredictable, and a tree or monument that has stood for 100 years or longer can be broken down in a heartbeat.

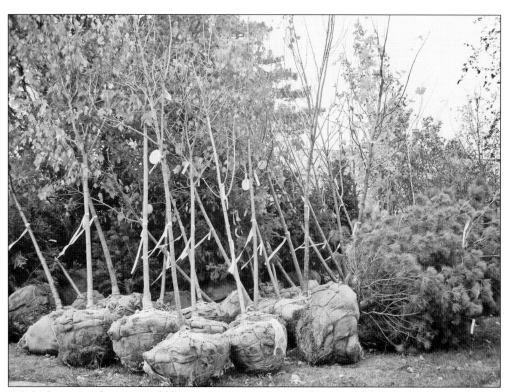

While the storm cleanup would be a major undertaking, volunteers and contributions poured in. Modern Woodmen donated 75 replacement trees and also provided volunteers from their family of employees on a number of occasions. The trees shown here were donated by Modern Woodmen and would be planted by volunteers from the company.

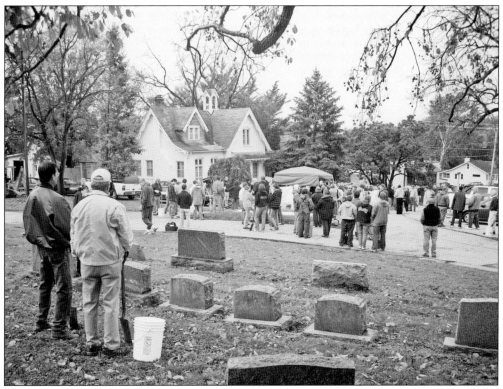

Three weeks after the storm, the Chippiannock staff was surprised by the flood of volunteers who came to the cemetery for cleanup day. "People just kept coming up the drive," said Greg Vogele, according to the *Quad-City Times*. "After that first day, then I started to see the light at the end of the tunnel." That day—August 9, 2008—there were 347 volunteer hours recorded.

A magnolia tree once stood on each side of the entrance gates to Chippiannock Cemetery. One of them was lost during the July 21, 2008, windstorm. After the storm, Modern Woodmen and local news station WQAD teamed up for a contest to donate trees to locations in need. Chippiannock received 42 percent of the vote, and 75 trees were donated to the cemetery and planted in October 2008.

On August 9, 2008, volunteers put in 347 hours of clean-up time. Chippiannock set up a special volunteer cleanup day after so many people called them, asking if they could come and help. Volunteers ranged from people with loved ones buried in the cemetery to neighbors and other concerned citizens.

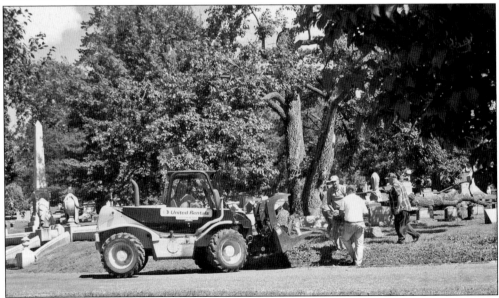

Chippiannock received assistance from major benefactors as well. They included the Rock Island Modern Woodmen of America; Valley Construction in Rock Island; A-1 Arborist in Moline, Eckhardt Trucking from New Windsor, Illinois; Bevel Granite Company from Chicago; and the Illinois Department of Natural Resources. Three Illinois cemetery crews came from miles away to help, including Oak Ridge Cemetery in Springfield; Chapel Hill Memorial Gardens in Freeport; and Oak Knoll Cemetery in Sterling.

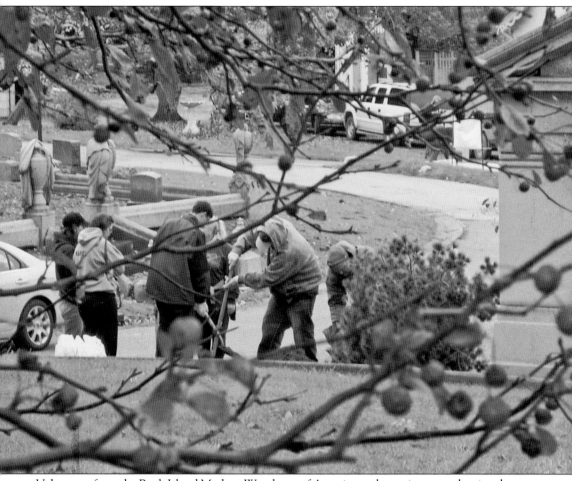

Volunteers from the Rock Island Modern Woodmen of America took part in a tree-planting day on October 25, 2008. Teams were formed to plant trees in various locations throughout the cemetery grounds. This team planted an evergreen next to the Huber mausoleum. Larger trees were also donated to Chippiannock, though they would be planted with the help of special equipment.

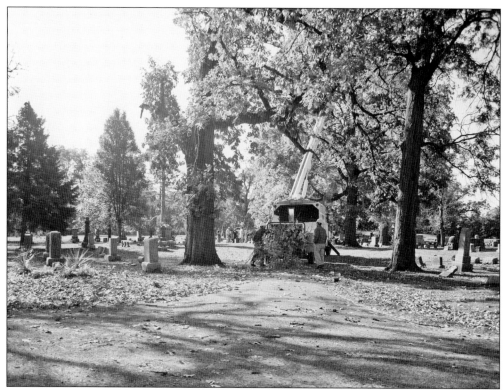

Not all of the work that had to be done after the storm could be done by the Chippiannock staff. The largest of the fallen trees had to be removed with special equipment. The individual contributions went toward the costs to rent big equipment, including cranes, and hire other professionals to come in and take care of the jobs the Chippiannock staff could not manage on their own.

One year after the storm, while there is still work to be done, Chippiannock Cemetery has regained its natural splendor. Superintendent Greg Vogele says that even though many trees are gone, new vistas have been created and the new trees are doing well. While some views may have changed, the beauty of the cemetery is indeed eternal.

Nine

A LIVING CEMETERY
A LIVELY COMMUNITY

Starting in 1994, the cemetery has indeed come alive. *Chippiannock Cemetery: Epitaphs Brought to Life* has turned the cemetery into a theater for a day, with actors portraying 14 historical figures during the event. This photograph is from 1995. *Epitaphs* has attracted thousands of visitors and educated them about the fascinating histories of the people interred in Chippiannock. (Courtesy of Chippiannock Cemetery.)

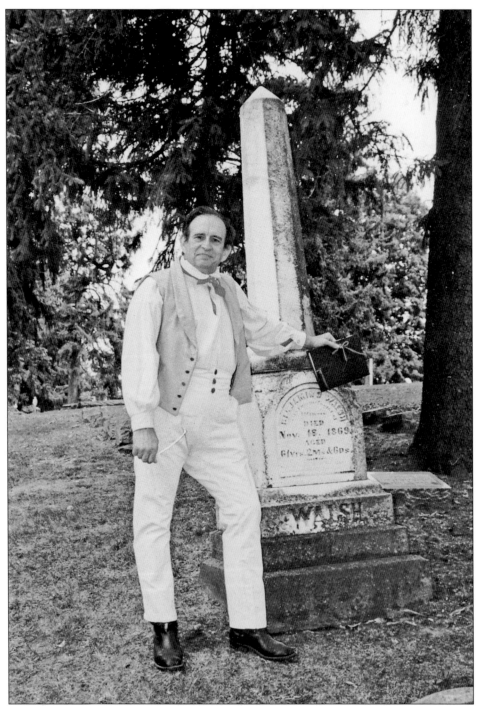

In 1994, local noted liturgical artist Bill Hannan portrayed entomologist Benjamin Dann Walsh during the 1994 *Epitaphs Brought to Life* program. His artwork can be seen on the Stations of the Cross in Calvary Cemetery across Thirty-first Avenue from Chippiannock. In June 1999, he also conducted a tour called "Art History at Chippiannock." Hannan also designed the cemetery's logo. (Courtesy of Chippiannock Cemetery.)

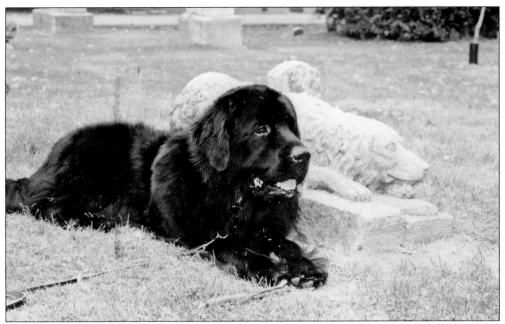

One of the most popular actors during *Chippiannock Cemetery: Epitaphs Brought to Life* is the one who did not have to act at all. While the Dimick children's dog is not buried in the cemetery, his statue is very popular. Eddie and Josie Dimick died at the ages of five and nine, respectively, of diphtheria on the same day in 1878. (Courtesy of Chippiannock Cemetery.)

The definition of an arboretum is a "place where an extensive variety of woody plants are cultivated for scientific, educational, and ornamental purposes." Chippiannock is an excellent example of a Quad Cities arboretum, with over 100 species of trees and a wide assortment of plant life and flowers. In July 1999, district forester Steve Felt (center) led a botanical walk of the cemetery grounds called "Into the Woods." (Courtesy of Chippiannock Cemetery.)

The city's public transit system, Metrolink, ran tours of historic Rock Island locations during the 1990s. Chippiannock Cemetery was a popular destination along the route that took passengers downtown and to different historic areas, including the Broadway District. A number of Chippiannock's residents lived in the Broadway District and had businesses downtown. (Courtesy of Chippiannock Cemetery.)

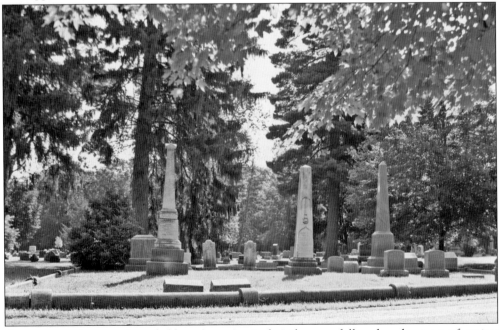

A common misperception of older cemeteries is that they are full and no longer performing burials. This could not be further from the truth. As a matter of fact, according to superintendent Greg Vogele, there is space in the Chippiannock Cemetery's grounds for at least 200 additional years of interments.

Not only is Chippiannock an arboretum, it is also a haven for wildlife. Deer are often seen roaming the grounds. Bird-watching classes have been held at the cemetery in the past because all types of birds can been seen and heard. Typically there are also plenty of groundhogs and squirrels, including black squirrels, which were originally a gift to the Palmer family (from Palmer College of Chiropractic in Davenport, Iowa) and were released on Arsenal Island.

As it was created on Manitou Ridge, the grounds of Chippiannock rise up the side of the gently sloping bluff, evening out at the top of the ridge. The slope of the land and the many types of trees make the cemetery one of the most beautiful places in Rock Island.

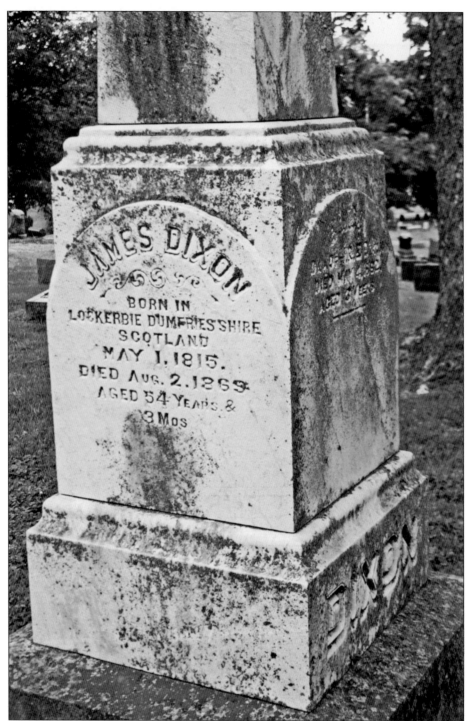

Chippiannock Cemetery is a treasure trove for historians and genealogists alike. For the genealogist, a gravestone such as this one for James Dixon is a true find because it not only tells the dates of his birth and death, it also states where he was born. Some monuments also note where the person died, if he or she lived out of state at the time.

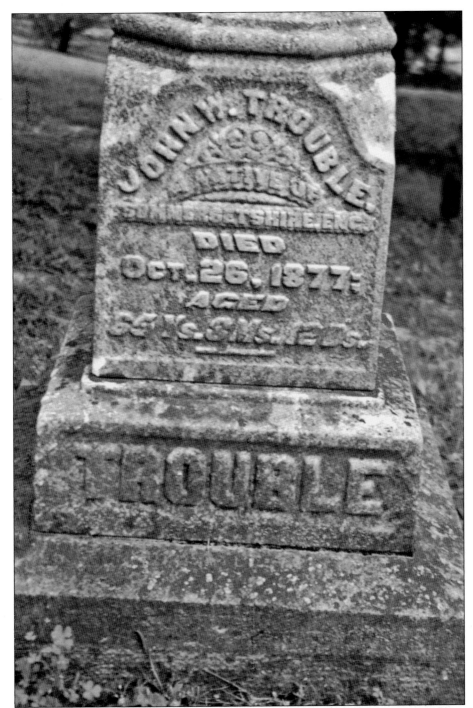

If someone is looking for trouble, they will find him in Chippiannock Cemetery. John W. Trouble, according to his gravestone, was a native of Sommersetshire, England. He died at the age of 65 years, three months, and 12 days on October 26, 1877. Trouble is only one of the interesting surnames found in the cemetery. When younger children come to the cemetery to explore, finding out of the ordinary names and symbols is a fun way to gain their interest.

People of all ages enjoy visiting Chippiannock Cemetery to walk or jog around the grounds and explore the various historic and modern grave markers. Shown here are Cindy Powers and her two-year-old granddaughter, Annabella Powers-Douglas, inspecting a marker in the shape of a panda bear.

The mausoleum located on the upper level of the cemetery features an image of the Sauk warrior Black Hawk and a quote by him. It reads: "With us it is a custom to visit the graves of our friends and keep them in repair for many years. There is no place like that when the bones of our forefathers lie to go to when in grief." The artwork is by Bill Hannan.

While it is true that no two Louis Comfort Tiffany windows are alike (Louis is the son of the Charles Tiffany of Tiffany and Company), one thing they have in common is their value. This is why the Tiffany window that was in the Denkmann family mausoleum was stolen in 1976. In 1996, it was finally located and returned to the family. Rather than reinstall it and risk another theft, the family donated it to what is now the Figge Art Museum, which has it on display. It is called the "River of Life." (Courtesy of Figge Art Museum.)

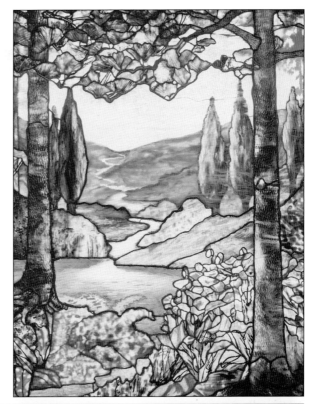

Throughout the year, there are certain holidays and occasions that are especially marked by Chippiannock. The Avenue of Flags is on display for Memorial Day. The tradition began in 1989, and most of the flags on display have been donated by the families of deceased veterans. Memorial Day is a very big day for Chippiannock and most cemeteries. It takes a lot of time and preparation to be ready for the large amount of visitors that come during the holiday.

123

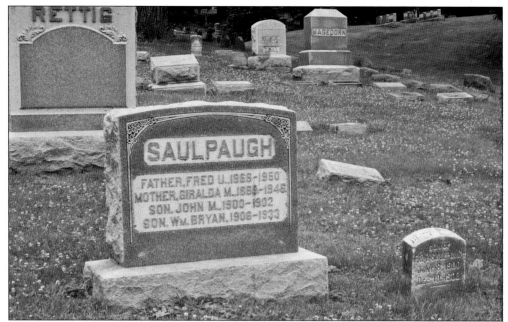

With so many interesting people buried at Chippiannock, it is no wonder the cemetery is a popular destination. Racecar driver Bryan Saulpaugh (1906–1933) is still remembered by those in the racing world. His first big win was in Sterling, Illinois. He was nicknamed Socko for bumping people's bumpers in races. He won state championships in Iowa, Nebraska, and Indiana, a "50-lapper" in Salem, New Hampshire, and a "100-lapper" on the West Coast. Saulpaugh died after crashing during a practice run.

Not all of the grave markers in Chippiannock are elaborately crafted monuments. Occasionally simple, understated markers that were made by the families of the deceased are also seen. This plain gravestone is made of concrete that has been painted white. While the cement was still wet, the names and dates of the Zismer children were written in with a stick or other thin object. The marker reads: "Martha 1867–75, William 1886–93, Albert 1890–93."

In 1999, the Chippiannock Cemetery Heritage Foundation was established to "fund efforts and projects to preserve the cemetery as a historical venue and maintain its landscaping and historically significant monuments while also serving the arts, education, sciences, and the general needs of the public," according to *150 Years of Epitaphs*. The Chippiannock Cemetery Heritage Foundation is a 501(c)(3) organization. Shown here is the marker for the children of C. P. and L. Kengstter.

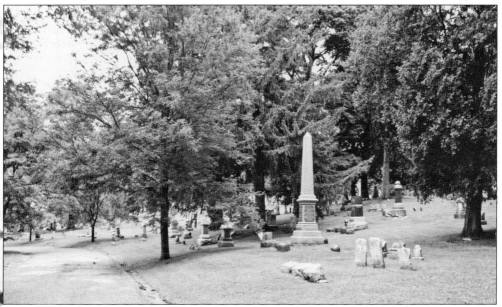

The Chippiannock Cemetery Heritage Foundation raises funds for historical and preservation programs. They also offer walking tours and classes, the most recent of which is "Death, Murder, and Mayhem: Graves Tell the Story of Gangster John Looney." Topics include Victorian symbolism, history, trees, birds, and genealogy. More information about Chippiannock's events may be learned by contacting the cemetery at (309) 788–6622 or visiting www.chippiannock.com.

INDEX

About the Chippiannock Cemetery Historical Foundation

For generations, Chippiannock has been famous for the design and artistic improvement of its landscaping and monuments. Through the years, it has also become a significant venue for artists, photographers, and lecturers. Each year, Chippiannock receives countless visitors from all across the country. In 1994, Chippiannnock was awarded a place in the National Register of Historic Places, and there are special challenges in maintaining such a landmark. Roads, trees, and shrubs need to be maintained and sometimes replaced. Monuments also occasionally need to be straightened and reset.

In 1999, the Chippiannock Cemetery Heritage Foundation (CCHF) was formed to raise funds for the historical and preservation programs, newsletter, and educational outreach provided throughout the years. The CCHF has 501(c)(3) status with the IRS, and all contributions are tax deductible.

The CCHF offers walking tours on history, Victorian symbolism, trees, and birds. Self-guided walking tour brochures are available at no cost. Genealogical and other types of workshops are also offered. If you would like to receive the CCHF newsletter, please consider membership in the CCHF. Membership is $25 per year for an individual and $45 per year for a family. Membership includes the newsletter and notification of discounts and special events. Please contact the CCHF for more information.

Chippiannock Cemetery Heritage Foundation
2901 Twelfth Street
Rock Island, IL 61201-5335
Phone: (309) 788–6622
Fax: (309) 788–6734
E-mail: info@chippiannock.com
www.chippiannock.com

www.arcadiapublishing.com

MAP SEARCH

Discover books about the town where you grew up, the cities where your friends and families live, the town where your parents met, or even that retirement spot you've been dreaming about. Our Web site provides history lovers with exclusive deals, advanced notification about new titles, e-mail alerts of author events, and much more.

MADE IN THE USA

Arcadia Publishing, the leading local history publisher in the United States, is committed to making history accessible and meaningful through publishing books that celebrate and preserve the heritage of America's people and places. Consistent with our mission to preserve history on a local level, this book was printed in South Carolina on American-made paper and manufactured entirely in the United States.

This book carries the accredited Forest Stewardship Council (FSC) label and is printed on 100 percent FSC-certified paper. Products carrying the FSC label are independently certified to assure consumers that they come from forests that are managed to meet the social, economic, and ecological needs of present and future generations.

FSC
Mixed Sources
Product group from well-managed forests and other controlled sources

Cert no. SW-COC-001530
www.fsc.org
© 1996 Forest Stewardship Council

Find Your Place in History.